Alternative Art Journals

MARGARET PEOT

NORTH LIGHT BOOKS

CINCINNATI, OHIO
www.artistsnetwork.com

Contents

WHAT YOU'LL NEED...

- .070" to .80" (1.8mm to 2mm) binder's board
- 1/2-inch (12mm) bright brush
- 1/2-inch (12mm) flat brush
- 1/2-inch (12mm) watercolor brush
- 2-inch (5cm) chip brush
- acrylic paints (Raw Umber, Primary Yellow)
- beads
- black fine-tip archival pen
- black pen
- bone folder
- book board
- brick or box for shaping
- bristol paper
- cigar box
- cloth
- colored pencils (black, blue, brown, cool gray, green, medium gray, red, warm gray, white, yellow)
- cookie sheet
- copper tape
- cord
- craft knife
- crayons
- darner needle
- decorative paper
- double-sided tape
- dowels
- drafting triangle
- envelopes of different sizes
- fine-tip Sharpie
- gampi paper
- gel pens (acid-free)
- glue stick
- grommets
- heavy books for weight
- India ink
- lemon juice
- mat knife
- mechanical pencil with 2H lead
- medium-weight canvas
- medium-weight drawing paper
- metal ring
- metal straightedge
- methyl cellulose
- museum board
- natural sponge
- old photographs
- paper towels
- pencil
- pencil sharpener
- photo album
- photo corners
- plain paper
- plastic bag for pencil shavings
- Plexiglas
- Postage Paper™
- printmaking paper
- Prismacolor pens
- PVA glue
- rice paper
- rice starch
- Rives BFK paper
- round brush
- rubber stamps
- ruler
- scissors
- scrap paper
- scrapbooking tape (acid-free)
- self-healing cutting mat
- sepia ink
- shoebox
- sketchbook
- small brush
- squeeze bottle
- stamp pads
- stencils
- string
- styrene
- tabletop paper cutter
- tags (blank)
- thread
- water-soluble colored pencils
- watercolors
- wax paper
- white gesso
- white gouache
- wood glue

Where to Find it...

Most of these materials can be purchased at your local arts-and-crafts supply store. Others can be found at hardware/DIY shops, stationers, office supply chains, or online.

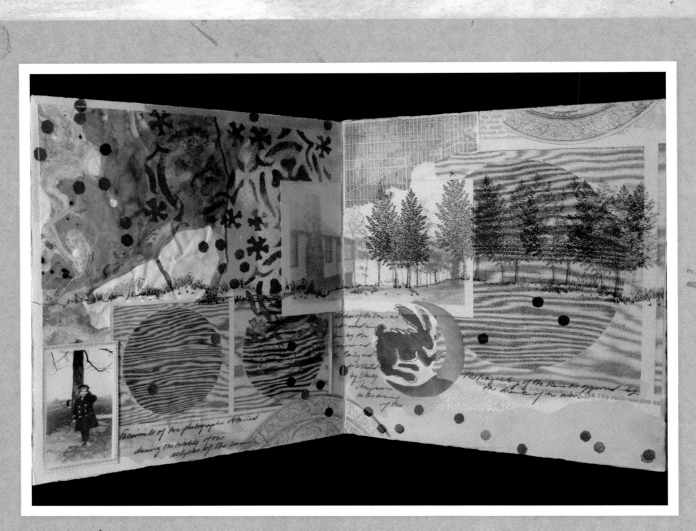

ASTRONOMY, PAGE DETAIL
12" × 12" (30cm × 30cm)
Coptic-bound sketchbook, mixed media

Drawing Inspiration From the Past

I found some old letters, photographs, dental X-rays and dried ferns stuffed in a book from the late 1800s. *Astronomy* was written in a flowery calligraphic hand on one of the yellowed pages. It inspired me to make several pages in this art journal—collages of antique papers, including color copies of the things I found in the book. I added stencils, stamping and handwriting to tie it all together.

Introduction

An art journal is a place where you can write and draw anything. It is your personal space—no one ever has to see it. It is a portable studio, a place of your own. You might already keep an art journal in the form of a traditional sketchbook, like those available at many book, art or office supply stores. But an art journal doesn't have to be a traditional sketchbook.

We all are inspired and moved in different ways. Some of us are messy, some neat, some are moved by silvery black and white photos, some are inspired by gloriously luscious paintings. Some of us like sequence and order, some like to shuffle and sort, and some like a wonderful jumble of stuff. Some of us prefer to work in three dimensions, and some like a flat page. Some like to stitch and embellish, some prefer a more austere approach. What you prefer is part of who you are, and the beginning of how you will make the choices about what you want to create as an artist.

Your art journal might be a long painting or scroll into which you paint and draw, working back and forth in time. You might make a faux family album or a journal of correspondence—perhaps you can write letters to your child-self, or into the future to yourself as an elder.

A less traditional art journal might be a shoebox into which you throw scraps of writing, doodles or interesting photos to sort and codify later. Or you might glue the objects and ephemera you have collected right onto a box. You could make a deck of cards that you can draw and write on, shuffle, or tell your own fortune with. An art journal can be a clothesline with ideas and pictures clipped all in a row—a string of charms.

This book will show you a wide variety of ways to collect and express your ideas. You will not learn how to make finished artwork, but rather alternative ways of collecting and storing your creativity and inspirations along your journey to self-expression. By the time you reach the end of the book, hopefully you will have found an art journal style that complements the way you think, create, explore and organize information. Something you see in these pages might ring a little creative bell in your soul and take you on an unexpected, but welcome, journey.

WHAT IS ART?

There are people who have spent much of their lives deciding what art is, what aesthetic means and what defines beauty. So let's spend a minute talking about art, and maybe gain a little freedom from that standard definition as you're deciding what your art journals are going to be...

You will work on your own definition of art all of your art-making life. Let's just say for now that making art is the creation of objects or experiences using skill and imagination based on a practice (like a meditation) of synthesizing information we get from our world. Let's add that art is intended to be shared with others, perhaps to elicit a response in them.

Sometimes the making of art is based only on intent. A stack of old photographs or newspaper clippings is not art. But if you put them together in a collage for instance, with skill, imagination and intent, they can be transformed into elements of artwork. Being an artist is being engaged in this act of creation.

An art journal can serve multiple purposes. In some cases, it can be an "artist's book," where every page is intended to be seen. The order of the pages and the images or text they contain is significant to the overall meaning of the book. The binding or form the book takes is important to the inherent meaning as well.

More often, though, an art journal is the private domain of an artist, where you can work out ideas, experiment with imagery, divulge personal truths. It is not necessarily intended to be seen, except maybe by loved ones, or to share an idea if you are working in collaboration with someone else. In this regard, if we go with our working definition of art, a sketchbook of this sort is *not* art, but perhaps something better—a garden in which you plant the seeds of art.

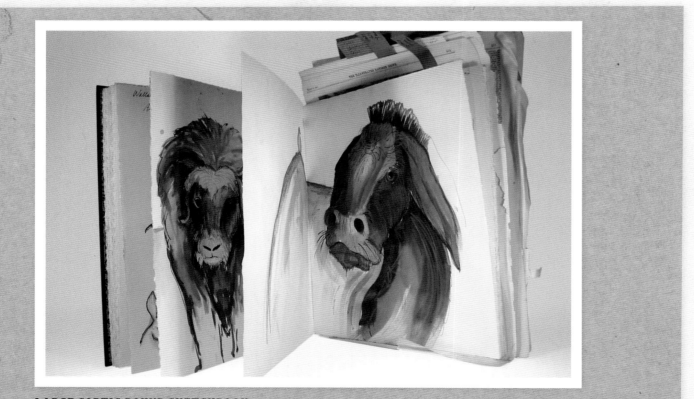

LARGE COPTIC-BOUND SKETCHBOOK
11" × 13" (28cm × 33cm)
Bound with various papers, including watercolor paper, Somerset and Rives BFK. These military oxen were rendered in pencil, watercolor and ink.

Receive downloadable bonus materials when you sign up for our free newsletter at artistsnetwork.com/Newsletter_Thanks.

GETTING PAST YOUR INNER CRITIC

There is a critic inside all of us—sometimes a whole chorus of them. Your inner critic might tell you that the art you make isn't good enough or worthwhile. This voice might be strong enough to discourage you from your art exploration. You know that negative voice. Lots of art and writing books address this issue, and talk about getting rid of the inner critic, banishing that creature to some dark recess of your mind. Sometimes this is successful. Sometimes it's not, and that little guy just comes roaring back in force, petulant for being rejected. Let's try something different.

Your inner critic might have the voice of a family member, a teacher or a child. Listen to yours. Who is it? Do a little meditation where you address the source of the voice and imagine leading it outside your head. If your inner critic has manifested itself as a family member or teacher, take them to an imaginary coffee shop, set them up with the newspaper and a cup of coffee. If it is a child, take them to an imaginary sandbox filled with fun toys. If it is a little monster, imagine a nice toadstool on which he can squat. Slip away and leave your critic there. Get back to your project. You can go back and get them later. You might even find that your inner critic does not want to come back to you—and that would be terrific! That voice has been protecting you from hurt and disappointment for so long, but you don't need it anymore. Thank it, find it something else to do, and move on without it.

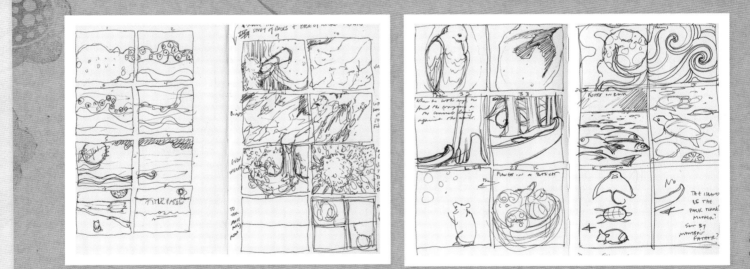

Get Comfortable With Roughs

A rough, also known as a thumbnail sketch, is a small, quick, gestural drawing that can be used to remind yourself of an idea for future reference, or to work out a composition or sequence of images. These pages of roughs from one of my art journals are a treasure trove of ideas. To an outsider looking in, they might not be the most gorgeous pages, but they are rich in information for future art making.

chapter one
Traditional Sketchbooks

Although the main focus of this book is exploring alternatives to the traditional sketchbook, this is not to say that sketchbooks aren't useful when it comes to collecting your creativity. They can be quite a valuable artistic tool—especially for recording inspirations that may strike when you're on the go. I recommend keeping one with you at all times. I always carry one, and I draw and write everything in it from ideas for my next woodcut, to notes about an exhibition I saw, to a list of clothes I need to pack for a trip.

LARGE COPTIC-BOUND SKETCHBOOK,
11" × 13" (28cm × 33cm)
Bound with various papers, including watercolor paper, Somerset and Rives BFK. These pages were rendered in pencil, watercolor and ink.

CHOOSING A SKETCHBOOK

You can find sketchbooks everywhere—in office or art supply stores, in book stores or online. There is something for everyone. (Moleskine makes a wonderful line of sketchbooks in a variety of sizes and paper weights with neat little pockets in the back where you can keep collage materials.)

There are three crucial factors to consider when choosing a sketchbook:

- **Paper type.** Your sketchbook should have paper that is archival or acid-free so that the pages won't yellow and become brittle over time.
- **Size.** Your sketchbook should be a size that you can easily work with. Avoid getting a book that is so small there will not be enough space for your ideas, or so large that you can't carry it anywhere.
- **The way it opens.** When you pick out your sketchbook, make sure that it opens easily and lays flat without you having to hold it open.

Check Before Buying

Small leather sketchbooks like these often lay flat because of the way they are bound. But you should always open them up in the store and check. It is awful having to wrestle with your sketchbook when you want to be wrestling with ideas.

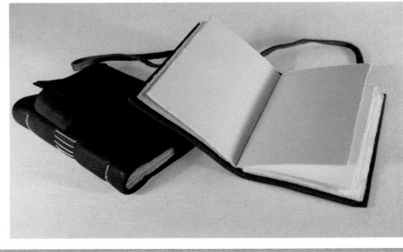

Choose Wisely

The variety of sketchbooks is dizzying. However, if you make sure your sketchbook is acid-free, not too tiny, and opens easily, the choices start to dwindle.

SUPPLIES

All you really need to work in your sketchbook is the book itself and the writing or drawing instrument of your choice. If you would like to do pages that are a little more involved, you can put together this small set of supplies.

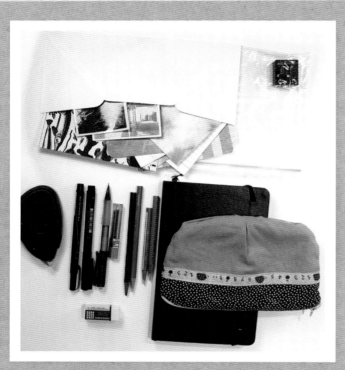

The Portable Art-Making Kit

To take advantage of unexpected art-making moments (that half hour in the waiting room at the dentist, for instance), you'll need a portable art kit. This should include your sketchbook and a small box or zippered case containing a few key supplies:

- Two acid-free gel-type pens
- One mechanical pencil with extra 2H leads
- Four colored pencils (blue, red, yellow and green)
- Pencil sharpener and a plastic bag to hold the shavings
- Small pair of scissors
- One roll of double-sided tape
- Small scraps of paper in an envelope

These things should keep you happily engaged in filling your sketchbook. The time will fly by, and you will be able to say that you have been spending time making art, honoring your creativity and your self.

Optional Additional Supplies

There are several optional supplies you may want to consider, depending on the size of your budget. You don't need to have all of them to have a wonderful art-making experience in your sketchbook, but having some of them can enhance that experience.

- watercolor set
- selection of artist acrylics
- India ink, sepia ink
- white gesso
- small envelopes
- needle (a darner)
- thread or embroidery floss
- stamp pads
- rubber stamps
- water-soluble colored pencils
- $1/2$-inch (12mm) watercolor brush
- 2-inch (51mm) chip brush (available in hardware stores)
- colored paper
- plain tags
- paper towels

DON'T BE INTIMIDATED

You have just purchased a beautiful sketchbook—its pages pristine and untouched. What now? Some of you will just begin with no problems, filling it up in no time. Some will take their new sketchbook home and promptly shelve it, perhaps afraid to use it.

There must be a way for you to dive in to this most personal of journeys without being intimidated by your supplies. How can you make this process your own? Can you give yourself permission to begin? What can you do to honor your ideas enough to commit them to the pages?

MESS IT UP

Mess up your sketchbook. Really. Age the pages with strong tea or a wash of brown watercolor paint. Or, you can try wiping a paper towel on an ink pad, then rubbing it across the pages. Do just a few pages at a time, letting them dry overnight. Continue until the book's pages are treated completely. Sand the cover, if you wish, rub ink into it with a paper towel, or paint it with acrylic paint.

I know an artist who throws his sketchbook into the bathtub and lets it dry all funky and wrinkled. You don't have to do that, but it is a new way to think about your book without limiting yourself by getting hung up on its perfection.

By doing this, you will know your sketchbook intimately, every page and stitch. You will have touched every inch of it, personalized it, and the pages will be yours to fill. It won't be so intimidating now—it is your old friend.

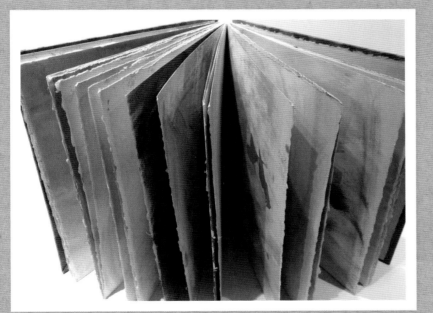

Aging the Pages

These pages, inspired by the fall color of hydrangeas, were aged with watercolor and then bound into a book, using a coptic-binding technique.

HYDRANGEA BOOK
11" × 11" × 1" (28cm × 28cm × 3cm)
Coptic binding, watercolor, dyed and printed book cloth

Coptic-Binding Demonstration

Visit artistsnetwork.com/AlternativeArtJournals for a bonus step-by-step demonstration on coptic book binding.

creating textured surfaces
Apply a Gouache Resist

A resist is a substance that blocks paint and ink and protects what is underneath. A gouache resist creates interesting surfaces to draw on and "omits" to write into.

In this demonstration, you will apply India ink on top of water-soluble gouache. When you rinse the paper under running water, the gouache will dissolve, revealing white paper underneath. The gouache won't totally block the ink though; some will eat through, leaving a wonderful texture.

Because gouache resist requires you to rinse the paper under running water, it is not a technique to use in an already bound art journal or with flimsy paper.

MATERIALS

flat brush

India ink

medium-weight drawing or printmaking paper

white gouache

2 Coat With India Ink
Apply India ink over the whole surface with a flat brush. You can use the India ink straight, as is done in this demonstration, or thin it with water to get a gray color. Let it dry thoroughly.

1 Apply Gouache to the Surface
Thin gouache with water to the consistency of heavy cream. Apply it loosely to sections of the paper with a flat brush. (You could also use a natural sponge to blob it on, or spray it on with a spray bottle.) Let the gouache dry thoroughly.

Receive downloadable bonus materials when you sign up for our free newsletter at artistsnetwork.com/Newsletter_Thanks.

3 Rinse the Paper
In a sink or bathtub, rinse the paper under running water until the water runs clear.

4 Drip Off Excess Water
After you rinse the paper, let it stick onto the sides of the bathtub or sink. This will allow any excess water to drip off.

5 Dry Out
Lay your rinsed pieces out to dry flat on a plastic covered surface.

Other Colors Work, Too

Any color gouache will work as a resist, but colored gouaches do leave stains on the paper. Stains are unpredictable, and sometimes can be quite dark, so do a test before using a color for this technique.

The same is true for ink. Any kind or color of waterproof ink will work—just make sure to read labels carefully and do a test before doing a whole piece.

create surface textures
Age and Distress Your Paper

Follow the steps to age and distress your paper. There are a few different techniques here that you can try. These will work on any type of heavy-weight art paper, as well as directly in the pages of your sketchbook. You can use any colors you like for these techniques, but consider the flexibility of your pages when choosing a color. It is easiest to work with neutral backgrounds and textures rather than bright bold ones, which can be challenging to overcome.

MATERIALS

22" × 30" (56cm × 76cm) Rives BFK heavy-weight paper

acrylic paints (Primary Yellow, Raw Umber)

chip brush

India Ink

natural sponge

paper towels

water in a squeeze bottle

AGING

1 Create a Paint Mix and Apply to the Paper

Create a mixture of Raw Umber and Primary Yellow (about 6:1). Thin it with water until it's the consistency of milky coffee, and brush it onto the center of the paper that you want to age.

2 Add Water

Use a squeeze bottle to sprinkle water onto the wet paint.

Empty Space

It is possible to cover every inch of a surface or page with rich texture. You can make a gorgeous surface, pulling out every technique you know. But sometimes that texture can overtake what you are trying to express.

Feel free to enjoy making rich textural pages, of course. But temper them with empty space. Don't be afraid of a lovely gray-day wash, or a white page gently dappled with shadow. Think of things that are a little bit plain, yet do not suffer for lack of richness or meaning…

• white sheets drying on a line in the sun
• a cloudless sky
• voluminous cumulus clouds
• a baby's smooth cheek
• a shaft of sunlight on a bare wall

These things are filled with meaning and gorgeousness all by themselves. They don't need a doily-stenciled border.

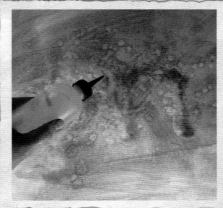
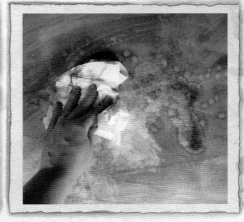

3 Rub In
Rub the water into the paper with a natural sponge. This is very much a wet-into-wet process, so keep moving.

4 Add More Water
Using the squeeze bottle, drip more water onto the paper.

5 Dab Off
Dab off the excess with a paper towel until you get a soft or dramatic effect for your book pages.

SPONGING

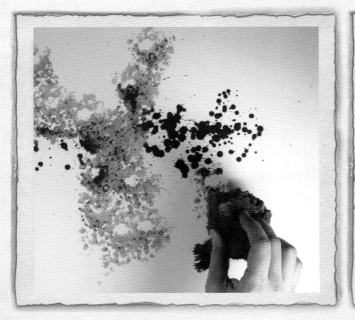
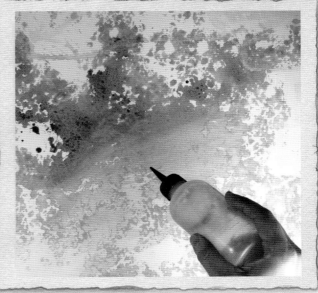

1 Apply Paint to the Page
Using a natural sponge and the same paint mixture as the previous technique, dab paint onto the page. You can cover the entire page or apply only in certain spots—it's up to you.

2 Add Water
Squirt the sponged texture with water and dab off the excess with a paper towel.

BLOTTING

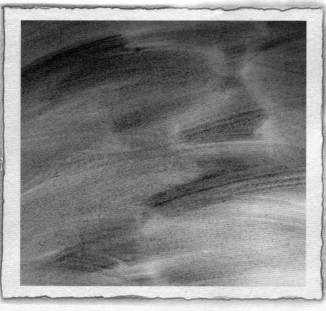

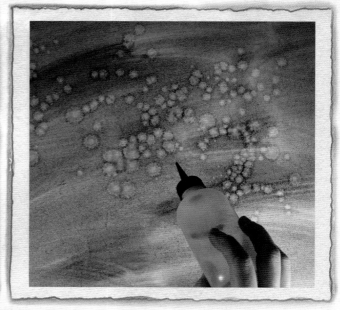

1 Create and Apply an Ink Wash
Drop some India ink into a container with water. (About a half teaspoon of ink to a cup of water.) Dip a wadded paper towel into this mixture and rub it gently into the paper.

2 Add Water
Drip some water onto the paper with a squeeze bottle, or from the end of a water-loaded brush.

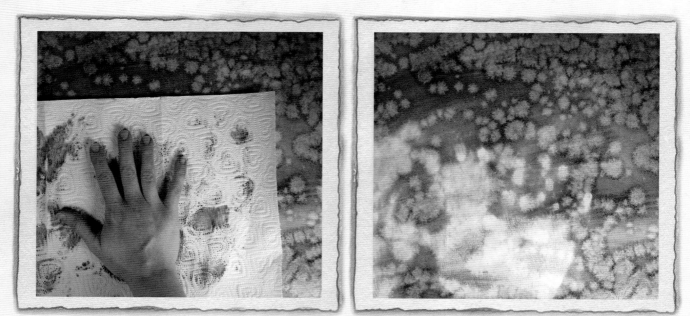

3 Blot the Surface
Lay a piece of dry paper towel on the surface and blot off the moisture. You can blot off the whole piece of paper, or just spots, leaving "omits" in which you can later write and draw when this is incorporated into your sketchbook.

Receive downloadable bonus materials when you sign up for our free newsletter at artistsnetwork.com/Newsletter_Thanks.

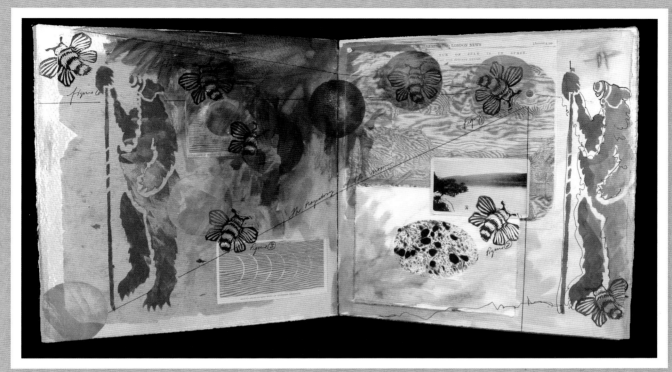

The End Result of Applied Techniques

This page spread started with aged pages in a washy brown. I collaged antique papers, a photograph and a marbleized egg. I then rubber stamped a bee, stenciled the bear, and scumbled watery brown acrylic back into this. The neutral toned aged pages I started with provided me with an interesting but non-intrusive background to work into.

ASTRONOMY, PAGE DETAIL
12" × 12" (30cm × 30cm)
Coptic-bound sketchbook, mixed media

Time Constraints

One way to get ideas flowing is the practice of setting time limits. When you sit down to work in your sketchbook, flip to a blank page and set a timer for ten minutes. Completely fill the page in that ten minutes—write, scribble, draw the huge monster that is keeping you from doing anything artistic in your life. Tear a hole in the page and decide what you might see through that hole on the next page. Write about it. Don't erase anything. Stop at the end of ten minutes. As you will be working hastily, concerned with the time constraint, interesting ideas will slip past your inner editor and onto the page.

chapter two
Shoebox Weeks:
Collections Art Journals

An art journal can be anything you want it to be, and contain any type and amount of elements. To get yourself into the daily habit of thinking about your art journal as well as what interests you artistically, try the following: Every day for seven days, collect things you like or that are personal to you, all with the idea of putting them into your art journal at the end of the week. Toss the things you find into a shoebox. Collect doodles, notes to yourself, a picture of your dream house, color chips from the hardware store, a feather you found in the park, an envelope with an interesting stamp—anything that moves you.

You don't have to use everything you collect, but you will start to find a certain pattern in the things you gather as you get to know your own creative self. Possibilities will start to unfold in a wonderful way, and your mind will be refreshed and galvanized by this process. You will find that your new, energized mind looks at everything differently, and this will begin to affect all aspects of your life.

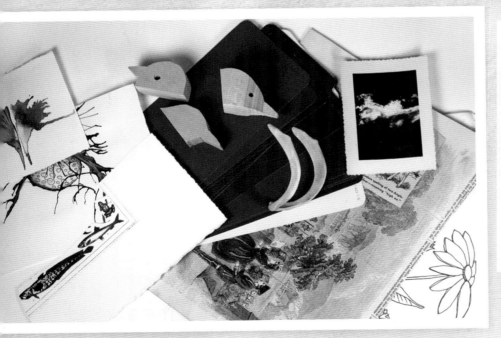

You Will Need:

- an art journal
- a shoebox
- double-sided tape or glue stick
- pen and pencil
- crayons and colored pencils
- plain paper
- vellum and regular envelopes

Collect Anything That Interests You

This is a sample collection of things I ran across one week that interested me. There was no apparent rhyme or reason—the unifying factor was that I liked them all.

Receive downloadable bonus materials when you sign up for our free newsletter at artistsnetwork.com/Newsletter_Thanks.

GETTING STARTED

Try to have at least seven objects in the shoebox by the end of the week, so that you have plenty to work with. Keep in mind that you will be putting these things into your art journal, so try to collect things that are somewhat flat. If you see something that isn't small or flat enough to put in your book, take a picture of it, write about it, or draw it. If they are precious or one-of-a-kind things, like a child's drawing or an old photo, consider color copying them.

The way you put things into your art journal is up to you. You may want an ordered account of what you've collected, with each item labeled and indexed, as if you were an amateur anthropologist examining an ancient culture. Or you may want to build up a dense surface of information obscured by paint and hidden behind flaps.

The objects you collect may also dictate what your presentation might be. For example, if you found seven leaves or seven feathers, you might consider putting them in seven vellum envelopes mounted on two pages of your art journal, then writing on each envelope the circumstance of the collection of each feather or leaf.

Any time you can include something drawn or hand written in your art journal, do so. Don't be shy about messy handwriting or what you fear may be inadequate drawings. No one will see them but you.

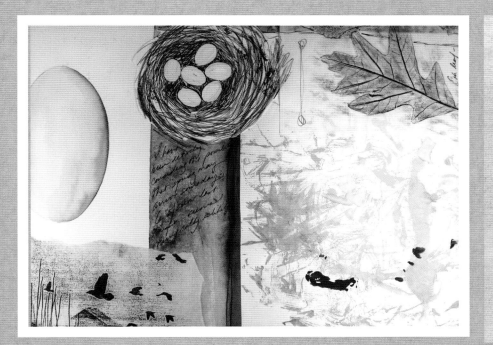

A Note on Archival Collage Materials

One important consideration: Many found collage materials will not be archival. If you will be including them with photos, you might consider having color copies made onto acid-free paper before you collage them into your book. If this feels too inhibiting to your creative process, then use the actual objects, and consider scanning the finished pages to print onto archival paper for posterity.

Spring Shoebox Week

This two-page spread reflects a late spring week—a rubbing of a leaf, a print made from a finger painting, a wishful-thinking drawing of a nest I did not see, and a drawing of an ostrich egg that a friend gave me.

THE RUBBINGS WALK JOURNAL

You could collect natural materials for your art journal and include them in envelopes, but another way to collect pictures is by making rubbings of the textures you find around you. On a rubbings walk, you can make rubbings of anything you see that has a texture—a seashell, a pier, the edge of your sun hat at the beach, the soles of your hiking boots, leaves, tree bark, lichen, small plants, manhole covers, a brick wall—the possibilities are endless.

To make a rubbing, place a piece of paper over the object or surface from which you wish to take an impression. You can make a rubbing directly into your art journal if the binding is flexible enough, or use loose sheets that you can then affix into your art journal with double-sided tape or glue. You may want to secure the edges of the paper or page with a couple bits of tape to keep it from slipping. Rub the side of a crayon across the textured surface.

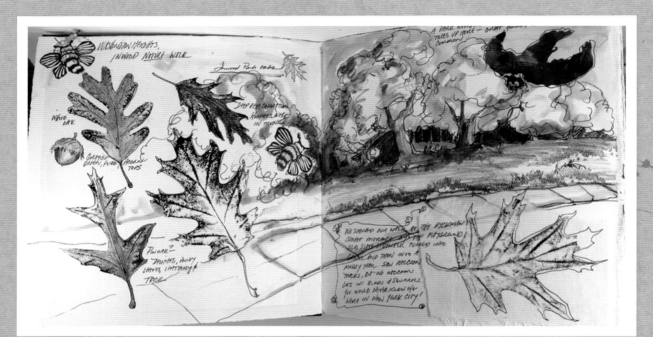

Rubbings Add Texture

I drew the path along a walk and collected leaves to make rubbings of, cut out and collage into my journal at home. The bee is a carved stamp, and the owl is a stencil painted with acrylic.

Historical Rubbings

There is a time-honored tradition of making rubbings of gravestones and brass markers to keep a record of what you saw and where you were. Some historic sites even have facsimile plaques so that ancient surfaces are not further eroded by rubbing. If you're interested in doing rubbings of gravestones or other historical markers, always ask first and familiarize yourself with techniques to preserve the old stones.

THE ENVELOPE JOURNAL

If you find that all of your art journal pages are filled with envelopes containing wonderful things, you might consider sewing a bunch of envelopes together as an art journal. You may want to use envelopes that are all the same, or choose different sizes, vellum envelopes that you can see inside of, or different colored envelopes to keep your creative secrets in. The backs and fronts of the envelopes can be painted, drawn or written on, and you can play with the idea of what is revealed and what is hidden in your art journal.

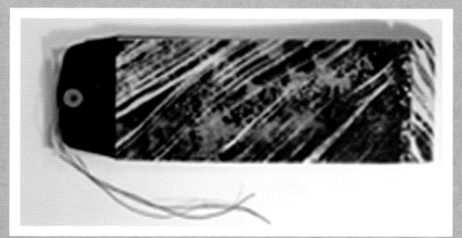

Long Envelope Journal

This journal was made by binding together long envelopes that opened at the end. Using a bone folder, I gently opened the sealed short ends and sewed them to an accordion structure. I stuck the folds of the accordion together with double-sided tape to hold the spine of the book together. (These envelopes were black, and I sponged and brushed a 1:4 bleach/water solution onto them.)

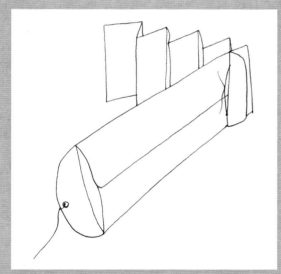

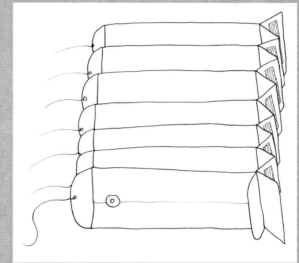

Make the Accordion Structure

Make an accordion-fold structure with a sturdy paper that is the width of the bottom of your envelopes. Gently open the sealed short ends of the envelopes with a bone folder. (Steam them open over a cup of boiling water if necessary.) Pierce the envelope and accordion in two places, and stitch together and knot each envelope individually.

Seal and Attach

After all the envelopes are attached to the accordion, seal them back together with double-sided tape. Then attach the accordion folds together with double-sided tape.

THE NATURALIST'S JOURNAL

Observing the nature around us can be a kind of meditation. In her book, *Crow Planet*, Lyanda Lynn Haupt suggests that we don't have to leave our house and drive up into the mountains to have an experience of nature, because nature is right outside the door—at the bird feeder, in the changing seasons, in the cracks of the sidewalk.

If we walk out the door with an art journal, pencil, and pair of binoculars or magnifying glass, we're prepared to see what we haven't seen before.

Recording your observations in a naturalist's journal is a wonderfully freeing way of starting a dialogue with your art materials. At first you are just collecting information and simply reporting what you have seen on your walks, or out your window. Then you might find yourself adding a fanciful butterfly to a page of observations, or reminiscing about catching frogs as a child.

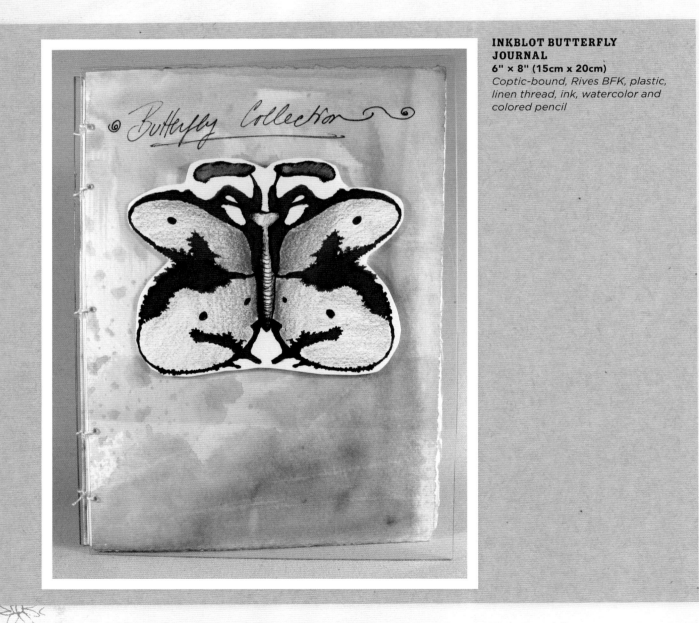

INKBLOT BUTTERFLY JOURNAL
6" × 8" (15cm x 20cm)
Coptic-bound, Rives BFK, plastic, linen thread, ink, watercolor and colored pencil

Figures shown in journal pages:

INKBLOTTUS FORMATUS:

Hademidae; Ophiinidae; Pluidae

This specimen found on my bedroom window sill. Unusual to see it in black & white— perhaps a new species? Caterpillars and egg formation unknown. Seems to like honey/water mixture...

Fig. 15

Fig. 14a

Papilionidae

(P. populi) Nabokoona

Found Oct. 4 in the elderberry next to the Frog Palace. Eggs and caterpillars form unusually large.

Fig 14b

Fig 14b

Combine Fantasy and Reality

Your naturalist journal can be very accurate—something that Darwin would be proud to see—or it can be a fantasy of truth and reality. This book is filled with drawings of natural things, as well as fantasy butterflies made by coloring in inkblots. This is not an art journal for which you will be given a grade in science class, so do what pleases you.

Visit artistsnetwork.com/AlternativeArtJournals for a bonus demonstration by Margaret Peot.

THE FILE JOURNAL

Accordion-file folders and check folders (available at any office supply store) also make great collections journals. You can decorate them any way you like, or keep them plain.

The linear arrangement of the folder compartments makes them ideal for a collection that takes place over a period of time. Sometimes the folders are labeled with numbers or letters. However, you can change the folder headings and make the file reflect things (or moods) of various colors, drawings, photographs, ideas for paintings, short poems—any or all of these things.

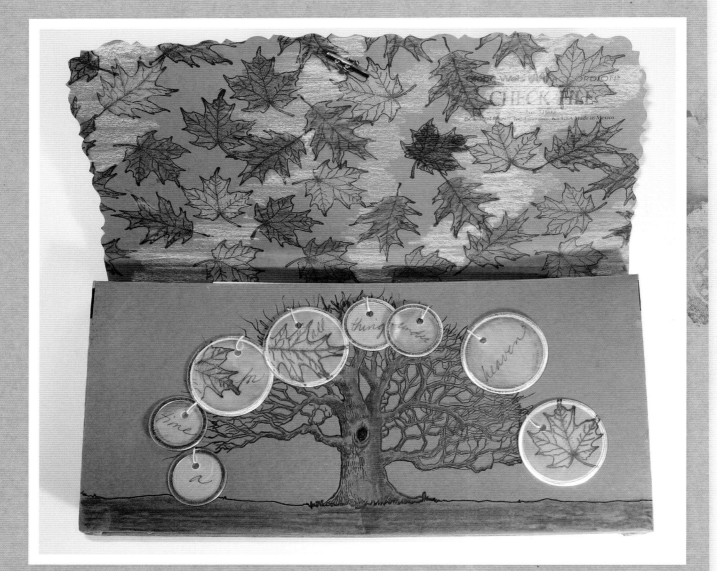

Collaged and Colored Decorations

The tags on this file journal were colored and stitched on. They read, "A time for all things under heaven."

Receive downloadable bonus materials when you sign up for our free newsletter at artistsnetwork.com/Newsletter_Thanks.

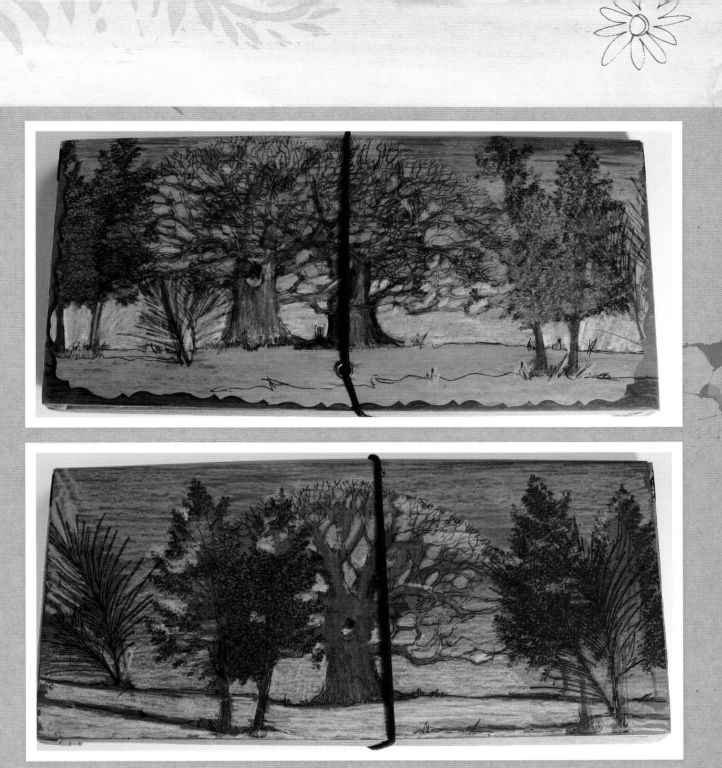

Stamped and Colored Decorations

This file journal is decorated with a spring scene on the front and a winter scene on the back. The interior documents the twelve months of the year. The trees were stamped on with purchased stamps, then colored in with colored pencils. The flap was trimmed with shaped scissors.

chapter three
Card Set Art Journals

You want to make art, but the days and weeks slip by, and other, "more important" things always seem to take precedence over your artistic journey. What if all you had to be responsible for this week, artistically, was to draw, write or decorate the front and back of one small piece of paper? Could you do it?

This chapter will help you record a year of your life. Every week, your task is to create one card—just one card! The small size of one card ensures that you can take it everywhere, and the world can become your art studio. Doodle and write on your card. Collage, stitch, perforate, even drive over it—anything to make a memorable mark. In a year's time, you will have a complete deck of fifty-two cards.

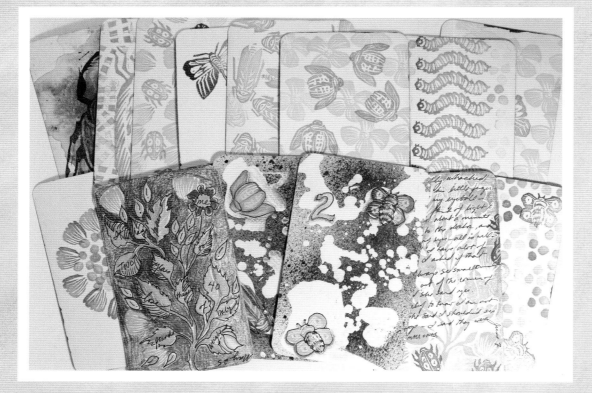

Tie Together in Various Ways

Your cards can be unified in any number of ways: by theme, by palette, by repeated imagery. In the card set *In the Garden*, carved rubber stamps of bees, bugs and flowers were used in different combinations. A large flower stamp is usually on the back, and the bugs and bees are usually on the verso, but I did not adhere to any strict rules.

GETTING STARTED

Buy a high-quality stiff paper from an art supply store, such as a four-ply bristol paper, or a heavyweight printmaking paper such as Rives BFK or Somerset. Using a tabletop paper cutter, make a jig to cut the paper to the same card size. (See the card-cutting demonstration that follows.) Cut all fifty-two cards at once, and cut a few extra just in case. It is easiest to cut them all to one size before you begin.

The size of the cards is up to you, though slightly oversized cards give you more room to record your thoughts. You might want to try a square format, a rectangle, a diamond, a circle or an oval. You could even consider making your cards each have a different amoebic shape. Perhaps you have a wonderful box already that you wish to keep the cards in—this could determine the exact size of your deck of cards.

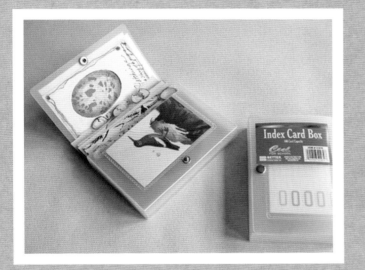

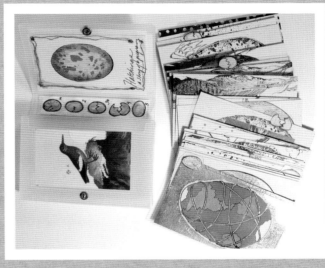

Choose a Box to Fit Your Card Set

For this card set, I bought and altered a plastic index card box from an office supply store. I made copies of egg drawings onto cardstock and used colored pencils and heat-sensitive foil to decorate the cards. The suits are organized loosely around the idea of the arc of the hatching of an egg.

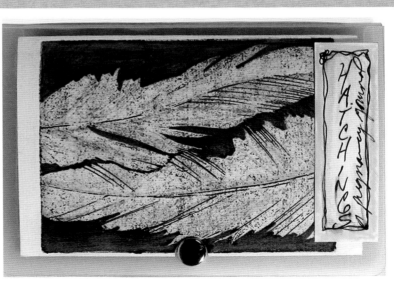

it's all in the cards
Cut Your Cards

One thing that can unify a card set is to make all of your cards exactly the same size. Rectangular and square cards can be cut almost perfectly using a tabletop paper cutter and following along with these steps. (If you don't have a tabletop paper cutter, a local frame shop, school, office or printing center is bound to have one you can use.)

MATERIALS

bone folder

bristol or printmaking paper (enough to make about 60 cards)

drafting triangle

masking tape

ruler

tabletop paper cutter

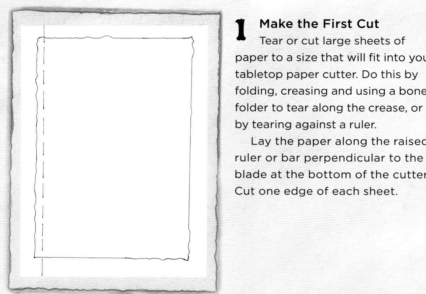

1 Make the First Cut

Tear or cut large sheets of paper to a size that will fit into your tabletop paper cutter. Do this by folding, creasing and using a bone folder to tear along the crease, or by tearing against a ruler.

Lay the paper along the raised ruler or bar perpendicular to the blade at the bottom of the cutter. Cut one edge of each sheet.

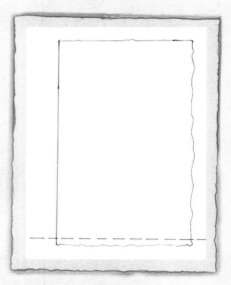

2 Make the Second Cut

Put the cut edge against the ruler bar of your cutter and make a cut perpendicular to the first cut.

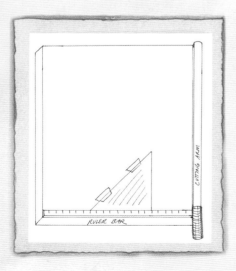

3 Cut the Width and Height

Determine the width you want your cards to be. Tape a drafting triangle onto the cutter so that the 90-degree corner is at that width.

Hold the squared edge of the paper (the two cut edges) against the triangle and ruler bar, and cut. Repeat for all cards.

If cutting square cards, there is no need to move the triangle. To cut rectangular cards, move the triangle so the distance between it and the blade is the height you want your cards. Tape the triangle in place. Hold the card against the ruler and triangle, and cut. Repeat for all cards.

Receive downloadable bonus materials when you sign up for our free newsletter at artistsnetwork.com/Newsletter_Thanks.

TREES AND COMETS CARD SET
26 cards, 4" × 4" (10cm × 10cm)
Rives BFK, rubber stamping, colored pencil, ink, gouache resist

Square Cards, Seasonal Theme

The backs of these cards all have leaf silhouettes, and the fronts depict trees and celestial symbols. They are organized loosely through changing seasons. The text is personal, relating to daily life.

Amorphous and Circular Cards

To make amorphous-shaped cards, create a pattern out of a piece of lightweight cardboard to trace around. For round cards, trace around a lid or plate of the desired size. There are also round and oval cutters, but it would only be worth it to buy one if you plan to make more than one deck of circular or oval cards.

UNIFYING DEVICES FOR YOUR CARDS

In most card sets, there is a unifying device. Usually the backs of the cards are all the same, or there is a border or other design on the face of the cards that is uniform for all. Your cards don't have to adhere to any of these conceits, but they can. Thinking about the design tenets set up by a deck of playing cards or tarot cards can inspire your ideas about how to begin your own set, by figuring out not only what to keep, but what things you want to change.

Create a Unifying Look All at Once

So that you don't have to struggle with a blank page (a tiny blank page can be just as daunting as a big one), you may want to create the basics of one whole season of cards at once. For example, you might spatter a paint texture all over the backs of your cards, and tea stain the other side. Or, you can buy or carve a rubber stamp that could define one side of your cards. This way, part of your art making can be responding to the marks that are already on the cards.

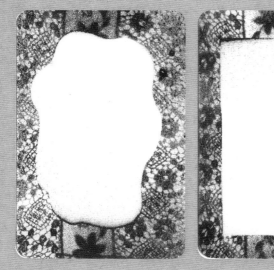

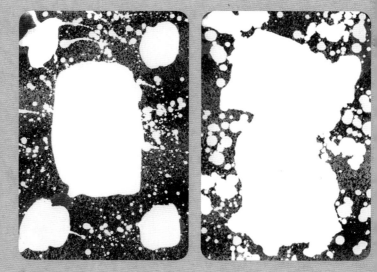

Acrylic and Lace

These card beginnings are made by laying a piece of rectangular or amoeba-shaped paper on cards. Lace was laid on top of that, and thinned black acrylic was sprayed through the lace.

Gouache Resist

These card beginnings were made using the gouache resist technique.

Receive downloadable bonus materials when you sign up for our free newsletter at artistsnetwork.com/Newsletter_Thanks.

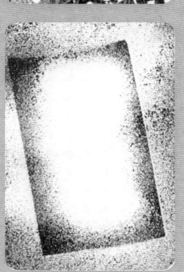

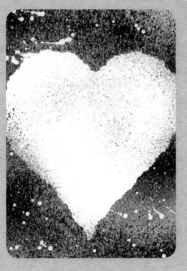

Sprayed Paint and Gouache Resist

These card beginnings were made with a combination of gouache resist and sprayed paint.

Stencils and Sprayed Paint

These card beginnings were made by spraying paint around simple stencils.

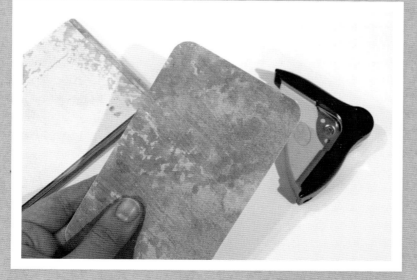

Finishing Touches

Rounding the corners of your cards creates a nice finishing touch. You can find corner rounders at hobby and art supply stores.

Visit artistsnetwork.com/AlternativeArtJournals for a bonus demonstration by Margaret Peot.

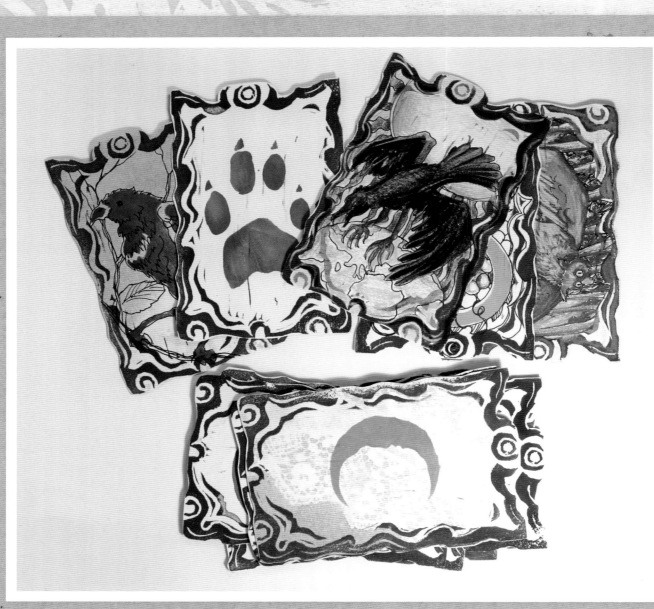

HIBERNATION CARD-SET JOURNAL
30 cards, 6" × 4" (15cm × 10cm)
Rives BFK aged with lemon juice, rubber stamping,
stencils, colored pencil, ink

Make a Deck With Friends

Excited about the idea of making a card set? Can't wait a year? Find three art-making friends and make a card set in a quarter of the time! Each participant can be responsible for creating one suit of cards and making four color copies of each card (front and back) onto cardstock. At the end of thirteen weeks, exchange your sets.

You may want to get together one evening to cut all the cards and decide on a unifying device. That device could be a visual thing, a design similarity, or something thematic. Perhaps you could do a summer vacations theme, or landscapes, or life changes. If you live far apart, assign one person to cut the cards for everyone and divide and send them out.

Lemon Juice, Lace and Acrylic

The paper was aged before being cut to size. I sprayed bottled lemon juice through lace and let it dry, then baked it in the oven for a short time until the golden color developed. The rabbit footprints and the moon are from stencils, printed with a small cosmetic sponge and acrylic paint.

Mylar Stencils

The crow and the hatching turtle were made with mylar stencils. The stencil plastic is transparent, so you can see through it to your planned design. It cuts easily with a craft knife. The nice thing about stencils and stamps is that they are reusable for making more cards.

SUITS

You might want to plan what your suits will be over the course of the year, or let them evolve as the seasons change and you change. Different leaves or colors could reflect the seasons. Animals, birds, blossoms and bugs in various stages of life might mark time and differentiate a suit. You could follow the path of one animal as the weather changes around it, as it finds a mate, prepares to give birth, feeds its young, stocks up for winter, hibernates, or makes a cocoon. Planets and stars and their movement through the skies would make a lovely deck. Or, abstract symbols, patterns or textures could define your card set. You may want your cards to be made up of images only, pictures and symbols that record a week in your life. In my cards, I always leave room to write. The writing sometimes takes precedence over the graphic images, but more often acts as a medium-toned background texture.

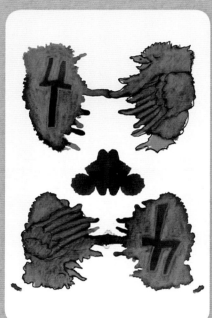
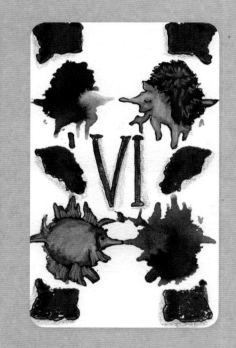
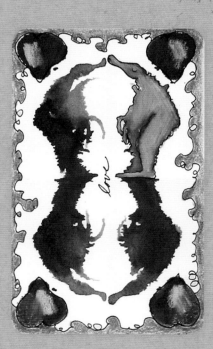

INKBLOT CARD SET
6" × 4" (15cm × 10cm)
Rives BFK, inkblots, colored pencil, ink

Unifying Inkblots

I cut all these cards to size, then made inkblots on the cards as the unifying idea. To make an inkblot, drop a little India ink and water on a pre-folded card, then fold it and unfold. Allow it to dry, then add color. Though the inkblots are somewhat random, they organized themselves into number cards and face cards, and the deck is loosely developing that way. The drawback to making inkblot cards is that the cards all have a crease down the middle.

chapter four
The Landscape Art Journals

A long piece of paper implies a narrative, a horizon stretching as far as the eye can see. It may contain the description of a long and complicated event, or indicate a journey through various kinds of landscapes—from a beach to a high mountain top, or along a curving river.

A long horizontal piece of paper could be used to convey the passing of time with representations of the four changing seasons, the hatching of an egg or a timeline of an event. On a vertical piece of paper, you could show a tall waterfall and all the creatures that live along its length, or a long dragon's body with a message on each of its scales. If you connect the ends of this piece of paper, you can write a poem or paint a landscape that never ends.

Long pieces of paper can be made into a portable book form in various ways. You can make a scroll, a folded accordion book or a Tibetan book structure that holds together a stack of pieces of paper between two board covers. Landscape journal formats work well with both images and text.

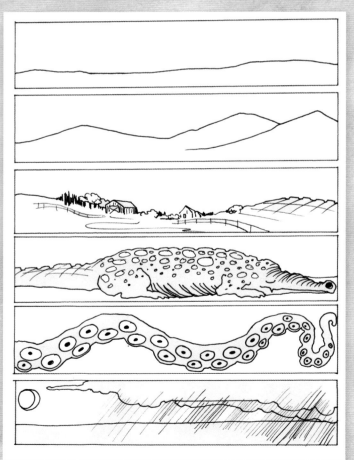

Landscape Journal Ideas

These are endless possibilities for ideas to organize your landscape art journal around. How could you make your landscape change from the left to right? Could you change the seasons behind a creature? Tell a long story along the arm of the octopus? Could you plow and plant and harvest in a farm scene? Could clouds obscure a gorgeous day, then drift away? Will you represent these changes with words or pictures, or both?

SCROLL ART JOURNALS

To make a successful scroll structure, you must use a non-Western paper, like Asian rice paper, gampi, papyrus, or a handmade paper such as abaca. You can also use leather or vellum. Western papers tend to hold their coil too tightly and get brittle with use, making them unsuitable for a scroll.

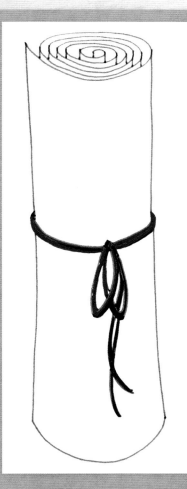

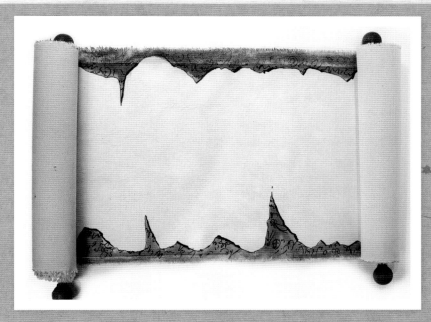

More Complex Scrolls

This scroll is a long piece of gampi paper mounted onto a slightly wider piece of canvas. It was inspired by a scroll I saw by the Naxi people of China on display at the Rubin Museum of Art in New York City. Someone had repaired the picture scroll with a scroll that was all pictogram-writing. So, with a pen and some brown watercolor, I made a trompe l'oiel plain scroll "repaired" by attaching to a worded scroll.

Simple Scrolls

A scroll can be as simple as a long piece of paper rolled and tied with a cord.

Scrolls in History

Scrolls were the first paper books, made in Egypt out of papyrus. Papyrus sheets could be rolled for easy storage and were sometimes tipped together with glue to make a longer roll, called a scroll.

Sometimes scrolls were written so that the text and images were parallel to the short ends of the scroll. Other times, the text and images were written in sections, horizontally. This may have been the beginning of scrolls being folded into an accordion structure, the folds dividing each section of text and images. The Dead Sea Scrolls are written like this, with sections of text side by side and the same width.

The scroll was used before book structures with bound pages were conceived of, and are still sometimes used today, such as the Jewish Torah Scrolls used for particular celebrations.

roll it out
Make a Scroll

The materials used to make a scroll should be flexible so that the scroll will be easy to unroll. Rice paper is ideal for scroll art journals because it rolls and unrolls easily without cracking or bending the way many Western papers do. You can make a simple scroll with rice paper and two dowels alone, but you can also back the rice paper with fabric using rice paste. In this demonstration, we will back the rice paper with Pellon Wonder Under, a double-sided fusible interfacing used for sewing. It is available at most fabric stores or online.

MATERIALS

beads (optional)

cord or string

dowels or fairly straight pieces of wood (2)

fabric (woven cotton or canvas)

flat brush

iron

Pellon Wonder Under

pencil

PVA (or other acid-free white glue)

rice paper

scissors

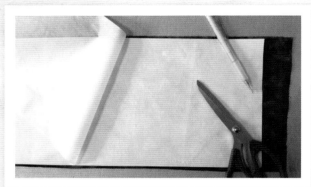

1 Cut the Fabric and Paper, Adhere Wonder Under

Determine the size, height and length of your scroll. Cut the fabric and rice paper a little larger than you want your scroll to be. Cut the Wonder Under a little smaller than the rice paper and fabric, but still larger than the scroll dimensions. Place the rough side of the Wonder Under on the rice paper and press with an iron. Remove the paper backing.

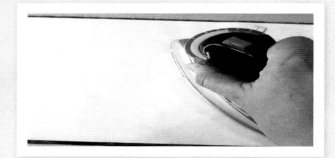

2 Attach the Rice Paper to the Fabric

Flip the rice paper and place it on the "wrong" side of the fabric. Make sure you have about an inch-and-a-half (4cm) of bare fabric at either end of the scroll length to more easily attach the dowels. Press with an iron until the rice paper is adhered to the fabric.

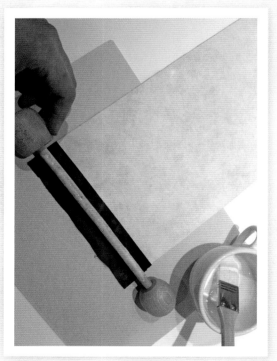

3 Trim the Paper and Glue the Dowels

Trim the top and bottom of the rice paper Wonder Under fabric sandwich to the desired height. Leave the fabric overhang at the ends for wrapping the dowels. (I used mismatched beads, a dowel and a straight piece of driftwood.) Paint glue on the dowel, wrap the fabric around it, and roll up the fabric until you get just beyond the edge of the rice paper.

Recieve downloadable bonus material when you sign up for our free newsletter at artistsnetwork.com/Newsletter_Thanks

4 Make the Dowel Perpendicular to the Scroll

While the glue is wet, use a T-square to make sure that the dowel is perfectly perpendicular to the scroll. If it is not, you can gently wiggle it around until it is. Attach the dowels to both sides and allow to dry thoroughly. Roll the scroll up on both sides and tie with a piece of cord to store.

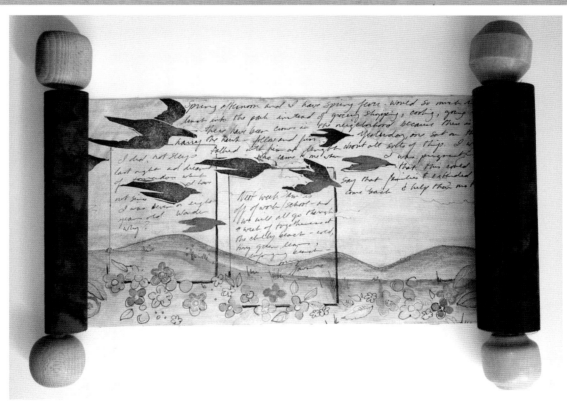

Scrolls are fun to draw on and fun to display. You can play with what you want to reveal and conceal, and work into different parts of the scroll as pleases you.

SPRING FEVER
40" x 10" (102cm x 25cm)
Wonder Under, gampi paper, cotton, stamp pad ink with hand-carved rubber stamps, colored pencil, fabric markers, pen

TIBETAN BOOK JOURNALS

Tibetan books are loose leaves of paper that are held between two decorated wooden covers and wrapped in silk. They can be religious texts, but also musical, botanical or other scientific texts. In older volumes, the text was often written by hand, but sometimes it was block printed on the paper when multiples of one text were made.

The loose-leaf structure of a Tibetan book makes a good art journal, as individual leaves can be taken out and carried with you, then re-inserted into the stack later and carefully wrapped again in silk.

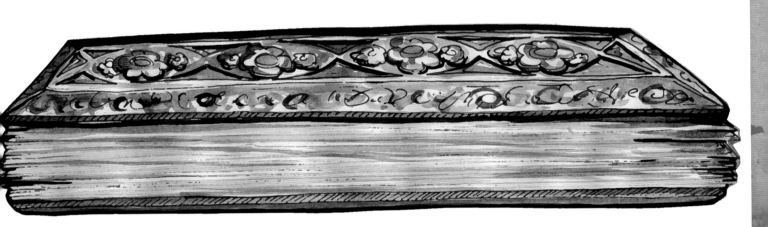

Drawing of an Old Tibetan-Bound Book
Tibetan books are comprised of wooden (or hard board) covers and loose leaves of paper.

Recieve downloadable bonus material when you sign up for our free newsletter at artistsnetwork.com/Newsletter_Thanks

Make a Tibetan Book Structure

Follow the steps to create your own Tibetan-book art journal.

MATERIALS

- bone folder
- book board
- brush
- decorative paper (two patterns)
- plain paper (cut to a uniform size)
- PVA glue
- rice starch
- scissors
- scrap paper
- tabletop paper cutter

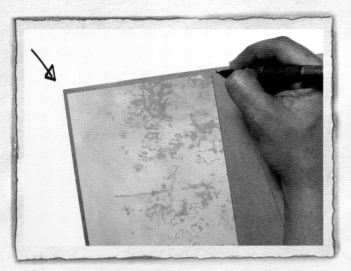

1 Mark and Cut the Book Boards

Cut your book boards on a large tabletop paper cutter. (A metal ruler and mat knife will work if you don't have access to a cutter.) Mark and cut the boards into rectangles about 1/8" (3mm) larger than your paper.

Determining Grain Direction

To get a sense for the grain direction of a piece of paper, roll one edge of the paper over without folding it and bounce the roll gently. Then turn the paper 90 degrees and roll and bounce that edge perpendicular to the first. One of the directions will provide less resistance to your bouncing. This means that the grain direction runs along the curled almost-folded line of the paper.

It is important that the grain direction of all the materials be parallel to the spine of a book. This is very important if you are gluing fabric or paper to boards, so that when the materials expand and contract with heat, moisture, cold or other environmental changes, all of the elements of the book can expand and contract in the same direction.

2 Cut the Decorative Paper

The grain direction of the board runs along its length. Because you'll be gluing paper to board, make sure that the grain direction of your paper runs in the same direction. Place the board and cut the paper using a pair of scissors. Leave about 1" (25mm) all the way around the board.

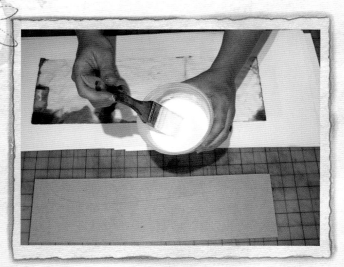

3 Mix the PVA With Rice Starch

Make a rice-starch paste and add it to the PVA in a 1:1 proportion. This will make the PVA less tacky and slow its drying time. Follow the manufacturer's instructions, but in most cases, you can mix 3 tablespoons of rice starch into 1 cup of boiling water. Stir until the lumps are gone. It is best to make this early, even the day before, so it can cool. The lumps will dissolve with occasional stirring over a few hours.

4 Apply the PVA Mixture to the Decorative Paper

Lay the decorative paper face down on a stack of scrap paper. Brush the PVA/rice-starch mix on the back of the paper and off the edges.

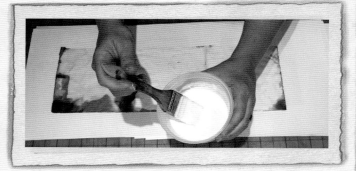

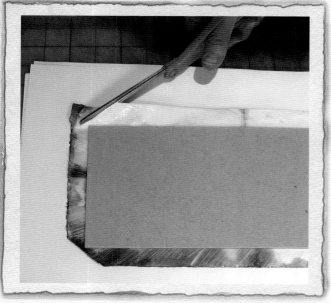

5 Adhere the Book Board to the Decorative Paper

Pick up the gluey decorative paper and discard the waste paper. Set the decorative paper face down on clean waste sheets. Place the board in the center of the gluey paper and press lightly down.

6 Cut the Paper Corners

With scissors, cut the corners of the paper, leaving about $\frac{1}{8}$ (3mm) of an inch from the corner of the board.

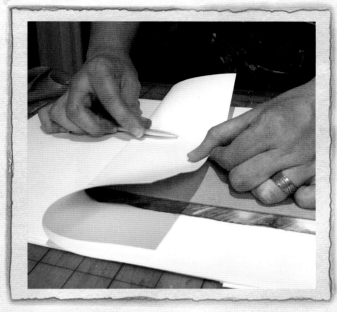

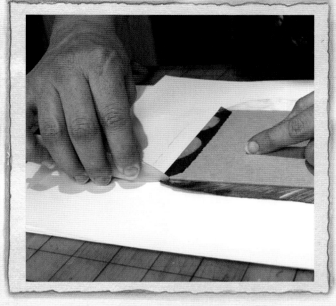

7 Bone the Paper Edges to the Back of the Board

Using the clean waste sheet (not your hand), pull one of the sides of the decorative paper up onto the edge of the board. With a bone folder, bone the paper to the edge of the board. Then lay the paper the rest of the way down on the board and bone the flap to the board face.

8 Pinch the Corners

Using your thumbnail or the tip of the bone folder, pinch the corner of the paper down at both edges. Repeat this process for the three remaining flaps. If you need to reapply a little glue, do so, but remember to remove the gluey waste sheets afterwards.

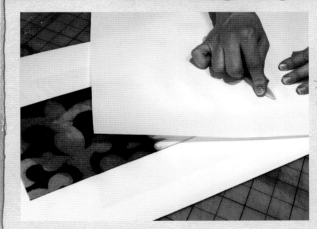

This is what it should look like once all of the flaps have been glued down.

9 Bone the Paper to the Front of the Board

Flip the board over. Place a clean sheet of scrap paper over the board. Vigorously burnish the decorative paper covering the front of the board by rubbing the flat of the bone folder on the waste paper over the board. Check for bubbles by gently running your fingers across the surface of the paper. Bone any bubbles away.

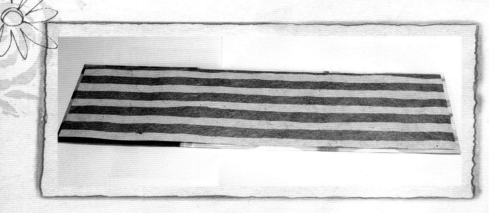

10 Cut and Attach the Lining Paper

Use a contrasting decorative paper to line the back side of the book board. (You could also line the board with the same paper you will use for the interior leaves.) Cut the lining paper (in this case, a printed Thai paper) using a tabletop paper cutter so that it fits on the board with about ⅛" (3mm) all the way around. Again, make sure that your grain direction is the same as the board.

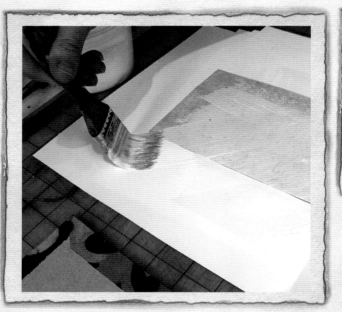

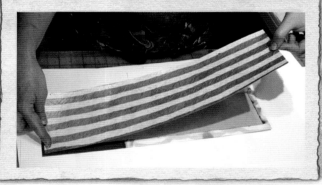

12 Attach the Lining Paper to the Board

Pick up the gluey lining paper and discard the gluey waste sheets. Move the board to the center of the stack of clean waste paper and carefully place the lining sheet on the board. Start by placing one corner first, then the rest.

11 Apply the PVA Mixture to the Back

Lay the lining paper face down on the stack of clean scrap paper. Brush the PVA/rice starch mix on the back side of the lining paper and off all of the edges.

13 Bone the Lining Paper

Using a clean waste sheet and the side of a bone folder, bone the paper down gently at first, then more vigorously to make sure it is firmly attached. Make sure there are no bubbles.

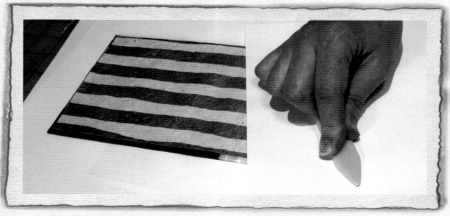

Recieve downloadable bonus material when you sign up for our free newsletter at artistsnetwork.com/Newsletter_Thanks

14 Make the Second Board

Now repeat all the steps to cover and line the second board. After both boards are finished, place them between several sheets of clean waste paper, place a piece of wax paper on top of this, and then weigh down the boards with heavy books or blocks. When the boards are dry, put your interior leaves between them.

Wrap the boards and leaves in a cloth if you like. You can tie it with a beautiful cord. For a more rough and ready journal structure, wrap it in canvas. If you are handy with a sewing machine, sew a sturdy canvas pouch a bit larger than the book with a flap that covers the opening.

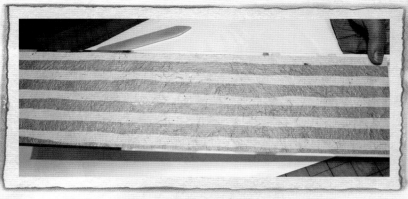

Lined Board for the Tibetan Book Structure

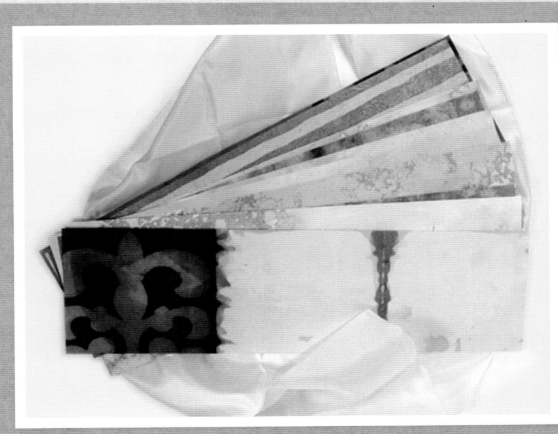

TIBETAN BOOK STRUCTURE
Made with paper-covered book board and aged Rives BFK. Wrapped in a white silk scarf.

ACCORDION BOOK JOURNALS

The accordion book structure evolved out of the scroll structure as a way to fold a long paper so that sections of the scroll could be viewed a bit at a time.

Many sketchbookers find that they like the accordion for this flexibility—the folded sections can be viewed and worked into as pages, but also folded out and observed and honed as a long landscape structure. The accordion is particularly portable, and unlike the scroll or Tibetan structures, can be displayed unfurled on its end so you can view the whole book at once. Moleskine makes an accordion fold sketchbook, but it is very easy to make one for yourself.

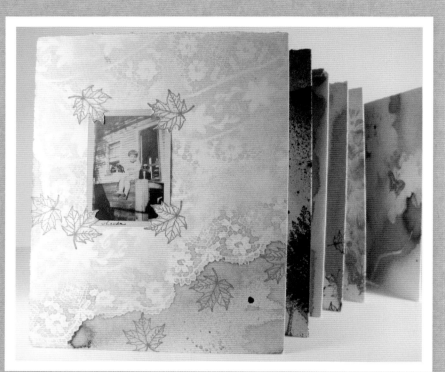

CONCERTINA FOLIO
Six 8" × 30" (20cm × 76cm)
accordion fold drawings
Lemon juice aging, stamping, India ink, antique papers and photographs

Coverless Accordion Journals

This series of accordion-fold journals do not have covers; they live in a large envelope. The golden texture came from spraying the pages with lemon juice, some through lace and some through weeds and wheat stalks. After baking them to get an aged appearance, the pages were stamped, painted and collaged with materials. They need to be bound somehow, someday, but I like them in their envelope for now.

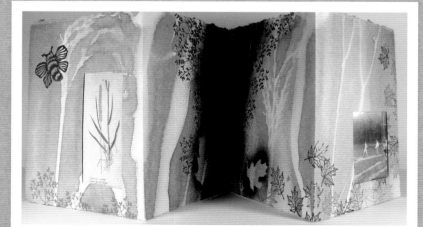

Recieve downloadable bonus material when you sign up for our free newsletter at artistsnetwork.com/Newsletter_Thanks

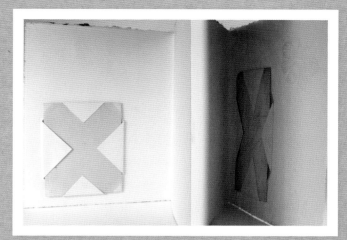

Setting Materials Into the Accordion Structure

This is a back view of one of the accordion structures that shows how the antique papers and photographs were set in.

Place the object—a photograph, say—on the back side of the accordion and lightly draw a pencil line around it. With a craft knife and a metal ruler, carefully cut from just inside one corner to just inside the opposite corner, then again from just inside the other two corners, making an *X*. Fold the triangles back and bone them down flat. Place your picture in the resulting frame and fold the corners again, securing the points to the photograph with double-sided tape.

Selection of Accordion Journals

The tiny journals in the front were made with long scraps of aged Rives BFK and have black museum-board covers. The journal in the back is a Moleskine brand accordion-fold sketchbook, called the Japanese Album.

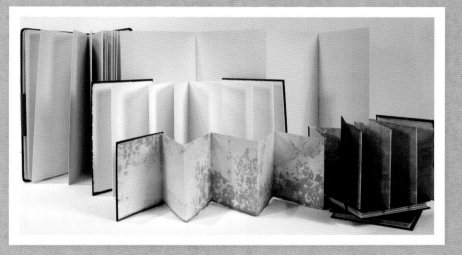

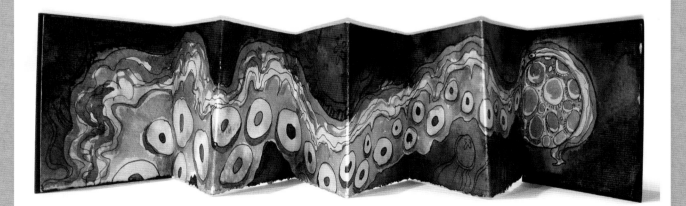

Small Accordion Journals Are Easily Transportable

Small accordion journals made from scraps are easy to carry with you to draw in and play with while on the run. Slip one into a sandwich-sized baggie and tuck it into your portable art kit. This octopus tentacle grabbing the moon was planned and drawn on the subway. I brought it home and painted in the blue-green background, then added text to the other side. The museum board was cut slightly larger than the accordion paper and attached with PVA.

fold it up
Fold an Accordion Interior

An accordion art journal can be opened out so that you can view one whole horizontal picture, or it can be bound so that you can view it page by page.

Generally, a medium-weight paper that holds a crease is best for an accordion structure, but the way you intend your accordion to function should determine the paper you use. If you want your accordion to be displayed on its edge revealing the whole of its length, choose a heavier-weight paper. But if it is not your intention that the pages be stiff and stand on their own, a lovely accordion can be made with the sheerest of rice papers. A smaller accordion will work better with a lighter-weight paper, a larger one can accommodate a heavier paper.

The folding method used in this demonstration will work for whichever paper you use.

MATERIALS

bone folder

medium-weight paper

1 Select Your Paper
Start with a long piece of medium-weight paper.

2 Fold and Crease
Fold the paper in half. A bone folder is very helpful for getting the creases sharp.

3 Fold Again
Fold the ends of the paper back to the middle.

Measuring and Cutting Your Paper

Rather than cutting a long piece of paper and measuring out the inches for each page of your accordion journal, begin by determining the number of pages you would like your journal to be. Let's say you decide on eight pages, and that you want each page to be 4" (10cm) wide. Cut your paper the number of inches times the number of pages—or 32" (81cm) long.

If you would like your journal to be several pages long but don't have a long enough piece of paper, you can tape two pieces of paper together. To do this, lay the two pieces of paper along a straight edge (such as a long table), butted together. Tape the butt joint with archival tape.

You can also cut a 1" (2.5cm) piece of paper and glue it to the butt joint with PVA, but you will have to wait until the glue is completely dry before folding.

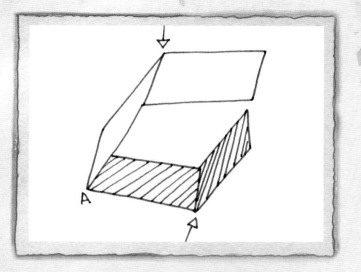

4 REVERSE THE FOLDS
Here's the tricky part: Reverse the folds you just made.

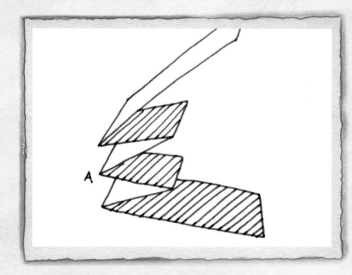
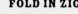

5 BRING FOLDS TO THE CENTER
Bring those reversed folds back to the center point.

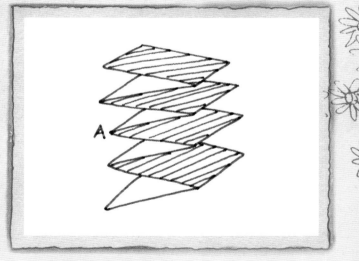

6 FOLD IN ZIGZAG
Fold the ends back as shown. When you fold this way, using the paper in front of you as your guide, you will have an accurate accordion. The longer the structure, the more folds you will have to reverse. Just use your common sense and keep the zigzag in mind as you go.

chapter five
Correspondence
Art Journals

The letter journal is great for people who like to write, or those who write and draw in equal measure. You can make many different kinds of letter journals where you imagine a correspondence between two imaginary people, or between yourself and a personal hero or fictional character. You can write letters to a future self, to a character in history, or to a person from your own past.

The physical structure of the letter journal can vary widely as well, depending mostly on the content. For a fictional romantic correspondence, you could use scented stationery and envelopes and tie them with a ribbon. You can mount the letters in an album so that they can be read chronologically. You can make a stack of beautiful postcards or, with a little fool-the-eye trickery, draw letters onto every page of a sketchbook to use as your daily journal for awhile.

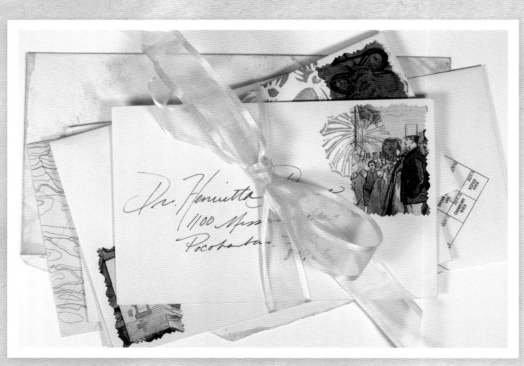

LOVE LETTERS
Envelopes and letter paper, ribbon, watercolor aging, rubber stamping, antique papers, ink

Receive downloadable bonus materials when you sign up for our free newsletter at artistsnetwork.com/Newsletter_Thanks.

AGING PAPER WITH LEMON JUICE

Sometimes I want to age every scrap of paper I use. There is just something so inspiring and evocative about writing with sepia ink on paper tipped with the gold of antiquity, rather than on a crisp new sheet.

It is easy to age paper with lemon juice. (You may have done it as a child.) However, because you are compromising the structural integrity of the paper by adding acid and browning it with heat, you should start with the best quality paper you can get. Use paper that is acid-free and has a high rag content. Otherwise, you may find your antiqued letters crumbling after a few years—as if they really are antiques!

Because of this, you might decide you'd rather age your letters with a wash of golden watercolor instead. But do try this method—it's magical, and may make you want to age every piece of paper in the house.

Vary Paper Size

Go to a stationary store that sells paper by the pound and get a selection of different-sized paper and envelopes. This way, your imaginary correspondents don't have to write to each other on the same paper.

AGED LETTER PAPER
Cotton rag stationery, lemon juice

Aging Paper With Lemon Juice

1 Preheat oven to 350 degrees F (177 degrees C).

2 Pour a little lemon juice into a container.

3 Use a ½-inch (12mm) watercolor brush to apply the lemon juice (undiluted) onto the paper. Think about where paper ages—around the edges, along creases. You may want to tri-fold your paper and paint lemon juice along the fold lines.

4 Allow the lemon juice to dry.

5 Place the paper on a cookie sheet and bake in the preheated oven. Watch closely as it browns. (You can even hold the door open a little and watch it magically develop.)

6 When it turns a golden color, remove the cookie sheet from the oven. Lift the paper from the cookie sheet with tongs as it will be hot.

CAUTION: Never walk away from paper in the oven. Sometimes it just takes a few seconds for the paper to turn color, and then it can easily burn.

LETTER JOURNALS

It is possible to make a letter art journal without any stationery at all. You can use a sketchbook in which you draw the letter paper, envelopes and postcards. You can draw flat rectangles, or use a little fool-the-eye trickery and draw a folded letter with a pen and ruler. If you choose to make a letter art journal, you can draw blank letters, postcards and envelopes on every page. Carry it around with you like a regular sketchbook. Write and draw where and when you feel the need to, sketching in places that you may paint into more thoroughly back at your studio.

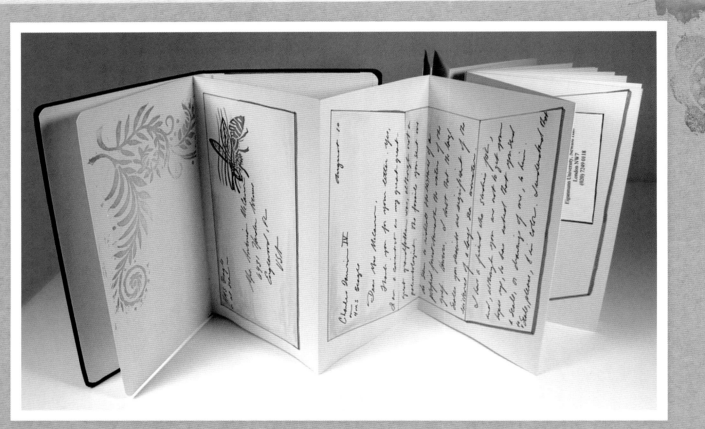

THE KRAKEN
8" × 5" (20cm × 13cm)
Moleskine Japanese sketchbook, ink, watercolor, rubber stamping, collage

The Story...

In *The Kraken*, a woman finds huge scales on the beach and writes to Charles Darwin's great-great-grandson to say she has seen a sea monster. He shuffles her off to an ichthyologist acquaintance who can identify her scales for her. The woman does not seem to have any technology at hand—no computer, email or camera—whereas the scientist has all of this at his disposal. He must rely on her terse text and drawings of what she has seen. She must deal with his growing disbelief in her.

The structure of the Japanese accordion album suits the content of the story. When I get to the end of the letters, what could be on the verso of the accordion? A long sea monster, perhaps...

Watercolor and Rubber Stamping

The rubber stamps on these pages were carved from Staedtler Mastercarve Blocks. The cancellation is red watercolor painted with a small round brush.

The Correspondence Begins

A Prismacolor brown pen was used to make the defining lines. The paper is shaded with watercolor.

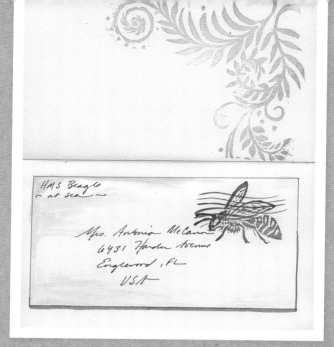

Differentiate Between the Correspondents

The stamps on these postcard backs were drawn, and random denominations were added.

You will have to find a way to differentiate between your two imaginary writers. Perhaps one of them writes in cursive and the other prints, as in this example.

Enhance With Details

I printed business card text with my Inkjet printer, affixed it into the book with double-sided tape and shaded around it. Feel free to add details like addresses, dates and other faux facts, but don't get so lost in these details that you get away from the meat of your correspondence.

POSTCARD JOURNALS

Postcard journals are similar to card set journals in that the cards are cut to a uniform size and can be carried with you, one at a time, to work on when you are away from your studio.

On the fronts of your postcards, create drawings or paintings of luscious landscapes, historical sites, maps, animals at a zoo—whatever you wish. The small paintings or drawings you make can really set the tone for your postcard correspondence.

Collaging antique papers, decorative papers and bits of less successful artwork onto your postcard fronts works well also. Always adhere collage materials to the base paper with a glue stick, as most glue sticks are made from methyl cellulose and are acid-free. More importantly, the glue is not wet, so it dries quickly and does not distort the paper or the collaged elements. You can cut the collage materials so they are flush with the edge of the card, overlap them and then trim them, or leave a tiny border of card all around the collage material.

Because postcards have a front and back, you may choose to keep them loose in a box, or you can display them in an album with clear sleeves. Sleeves are available in postcard sizes—just make sure they are labeled "archival" or "acid-free."

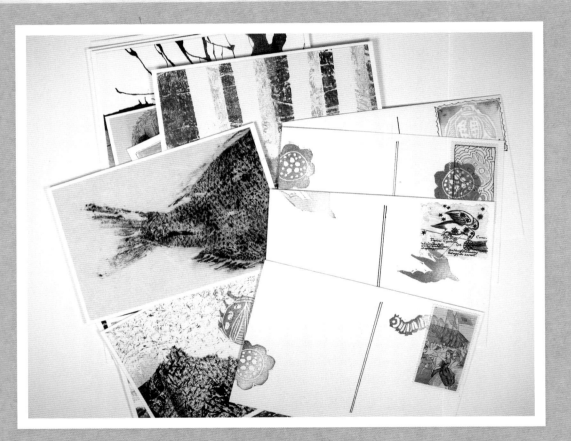

Variety of Collage Materials

Scraps of painted or decorative paper can be used as the fronts of your postcards. Less successful works on paper that you have held on to, technique samples, and other interesting bits can also be repurposed as postcard fronts. In this stack you can see a number of interesting textures, including part of a gyotaku fish!

POSTCARDS
4" × 6" (10cm × 1.5cm)
Rives BFK, collage, rubber stamping, postal paper, ink, watercolor, acrylics

Get inspired

The **Griffin & Sabine** books by Nick Bantock are wonderful artworks. They describe a relationship between two mysterious people, whose story is conveyed largely through their private postcards and letters. The postcards are gorgeous paintings, and the envelopes glued into the book hold letters within. Even the stamps are drawn and cancelled with Bantock-designed cancellation stamps.

Other written works that are composed entirely of letters, epistolary works, or where letters play a big role, are Ranier Maria Rilke's **Letters to a Young Poet**, **84 Charing Cross Road** by Helen Hanff, Honore de Balzac's **Letters of Two Brides**, Mary Shelley's **Frankenstein**, and Bram Stoker's **Dracula**.

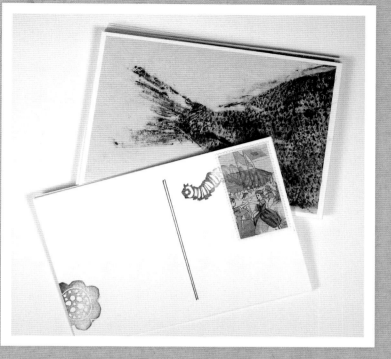

Postcard Front and Back

The stamp on the back of this card is comprised of a piece of antique paper cut out and glued onto a piece of Postage Paper™ from 100 Proof Press.

There Are Many Options With Postage Paper

Postage Paper™ is archival paper that has stamp shapes delineated with perforations. The Postage Paper from 100 Proof Press comes in different sizes and configurations. Here there are triangles as well as rectangles. Postage Paper is suitable for painting, rubber stamps or collage.

I aged the rectangle page with lemon juice so that it would take the edge off of the stark white.

POSTCARD DESIGN IDEAS

I prefer not to start my postcards from scratch. Instead I make a stack of postcards by collaging and painting a beginning, which I can then respond to later when I use them as an alternative art journal.

Here are some sample postcards that I have drawn and painted into. A couple were made with collaging antique papers, as well as paper that I textured with paint. Sometimes I repurposed a painting or drawing on paper that I only like a part of by using that part as a collage element.

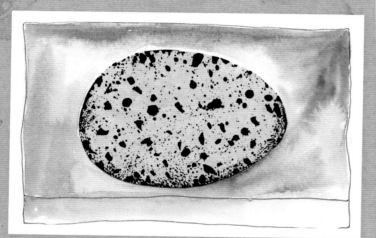

Before

This speckled egg is collaged in a simple sky that was painted directly onto the postcard.

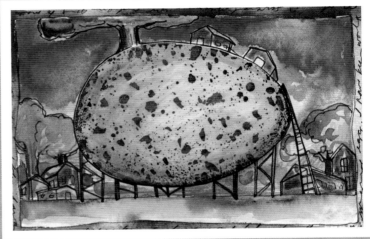

After

Watercolor, a Prismacolor ink pen and colored pencils plant this egg more firmly into the landscape.

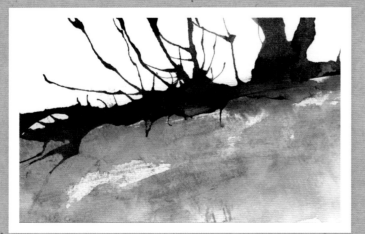

Before

The black branches were made by painting black India ink across the paper and blowing it with a straw to make tendrils. Once the ink was dry, I painted the brown with watercolor.

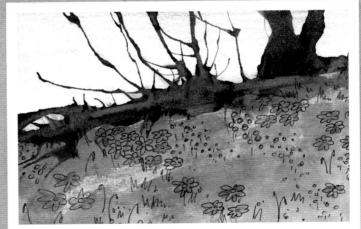

After

Watercolor, a Prismacolor ink pen and colored pencils transform this postcard into a spring meadow.

Before

The black-and-white texture is achieved here with a foam roller wrapped with burlap and rolled on with dry and wet rollers in acrylic paint. The horizon was masked off with a piece of torn paper. I stamped the beetle into the sky like a giant moon.

After

Watercolor, a Prismacolor ink pen and colored pencils make the giant beetle moon into a microscopic bubble, or an egg caught between two tiny branches.

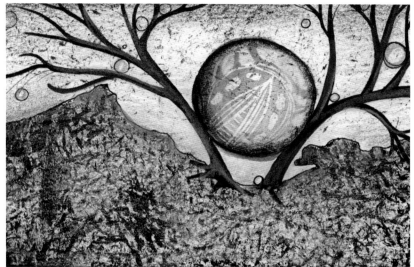

Before

This cow was cut out of an antique French farming magazine, and I placed her in a grand hall cut out of an antique newspaper. Sometimes juxtaposition of unlike things can be very evocative for inspiring ideas.

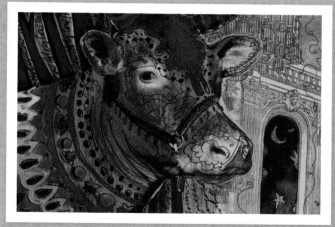

After

Watercolor, a Prismacolor ink pen and colored pencils transform this farm creature into a magical, celebrated beast.

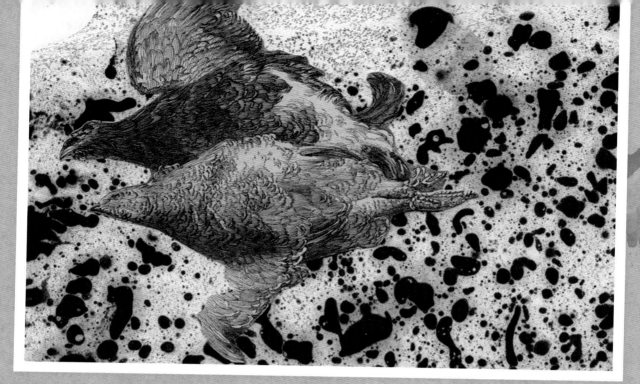

These two quail, cut from an antique hunting magazine, are collaged onto a marbleized paper experimentation.

The wintery abstract trees are taped off, and acrylic paint applied with a foam roller wrapped with string.

Writing Prompts

If you are having trouble deciding what to write or how to approach your letter art journal, try these writing prompts. The stories that will begin to reveal themselves to you may dictate every part of your journal—its size and shape, the weight of the paper, whether it is aged or not, what the stamps and postal cancellations look like, or even the images and places on the postcards.

1 A teenage girl who is an amateur entomologist discovers a new kind of beetle (or butterfly). She carefully draws and measures it, photographs and documents where and when she found it, and sends this information with a letter to the preeminent entomologist of the day. What do the drawings look like? What does the professional say? Is it really a new creature?

2 A poor woman gives a poorer boy ten dollars. He leaves home, goes to college and makes good. He writes to the woman. What does he tell her? Does he send back the ten dollars? Or more? What happened to the woman?

3 You discover that there is a way to send letters into the afterlife—a black Victorian-ornate mailbox sits on the corner, glowering, and you wonder how it is that you could ever have missed it. You can write to anyone from history! The only hitch is that the recipient will only be able to see what he could have seen in his own time. For example, if you sent a letter to Copernicus, accompanied by a photograph, he would not be able to see the enclosed photograph. But he would be able to see pencil or ink written or drawn onto a high rag content paper. Who would you write to? What would you tell them or show them?

4 With your life experience, you have learned some things you did not know when you were younger. Some of the things would have been useful to know back then! If you could write a letter to your younger self, what would you say to yourself? What if your younger self could write back? What would be in a letter from your younger self to you?

5 You receive a letter written on a leaf with oak gall ink. The writer claims to be a fairy who is making contact with you contrary to the laws of her realm. What does she say? Why has she chosen this time to write? What do you say back to her, and on what do you write?

6 You have the opportunity to write five questions, in five letters, to a venerated ascetic Buddhist monk who lives high in the mountains of Tibet. He will write back five responses. What will you ask him? What could you send him that would be welcome? A series of drawings? Your letters will have to look very special to be received by such a person—what will they look like?

7 The owner of a gallery in Paris has seen your artwork online. He has invited you to submit artwork to him to assess. He does not want a DVD or slides, though—he wants you to send eight original artworks, in eight individual envelopes, accompanied by letters. What do you send him? He responds to each one as he receives them. What does he say about your work?

chapter six
Box Art Journals

Artist and sculptor Joseph Cornell made assemblage boxes from found objects and ephemera. Photographs, etchings and fragments of objects all made their way into his boxes, which evoke story and mystery. Cornell was a collector at heart, assembling over 160 visual files on subjects that interested him.

Does this feel familiar to you? If your best ideas and inspiration come to you through collecting and rearranging things, then your perfect art journal might be a sketch box rather than a book format. Many artists make these types of boxes.

In this chapter, we will focus on making a journal of objects held in a container. We will construct a simple tray and lid, explore the possibilities of wooden boxes, and look at ways of mounting materials in a box.

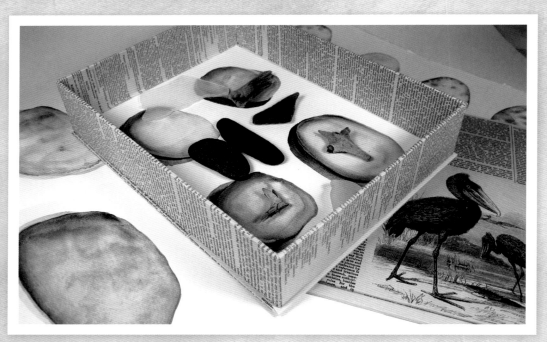

Tray-Box Journal

This simple tray box was constructed to hold some of the things I collected while walking on a beach. I wanted it to have a whimsical, almost childlike feeling, yet convey the sense that this is a collection of serious scientific objects. The antique newspaper is from the late 1800s. It works wonderfully for collage, not only for the illustrations but also because the paper has cotton content and doesn't deteriorate like our modern newspapers do.

NATURAL HISTORY
10" × 8" × 2"
(25cm × 20cm × 5cm)
Book board, antique papers, water-color, Rives BFK, Elvace, objects

FINDING BOXES

You can find boxes everywhere, at little to no cost. Cigar boxes, fancy boxes that gifts or chocolates come in, shoeboxes and wine crates are all no-cost boxes. Cookie, tea and spice tins are available at a low cost, and a variety of unfinished wood or papier mâché covered boxes can be found at craft and hobby supply stores. For a bit more money, you can get beautiful shadow boxes or wooden boxes at art supply stores as well.

Found Boxes Versus Making Boxes

There are pros and cons to using "found" boxes versus making your own box. You will be bound by the dimensions of a found box. This can be great in some cases—the size and shape of the box might inspire the contents you choose to place inside it. However, it can also be frustrating if the items you wish to box are a particular size and don't fit in the boxes you have found.

Ideas for Box Journals

Many of us have objects we have collected over time that tell stories and carry weight and meaning for us. If your best method of coming up with and working through ideas is by collecting and rearranging things you have collected, then your perfect art journal might be a box journal.

- Perhaps you have picked up an object every time you visited one special place over many years, and can recall the circumstances of each object's discovery. If you have these objects gathered together, could it be a kind of art journal? Does the order matter? How would you contain these things?

- The Blackfoot people from northwestern North America keep collections of objects wrapped in skins called Beaver Bundles. The objects within have mystical significance, each representing a story or song known only to the keepers of the bundles. We can only guess at what they might be, as the objects are revealed only to initiated Blackfoot people. What objects might make up your own magical bundle?

- Marcel Duchamp collected his working notes from the making of **The Bride Stripped Bare by Her Bachelors, Even (The Large Glass)** into a green flocked cardboard box. He duplicated this wonderful collection of scribblings and tiny sketches rendered on uneven bits of paper of varying weights and colors, and made an edition of 320 identical boxes. Do you have a collection of writings and drawings about a subject that you would be like to collect into a box?

"FOUND" BOX JOURNALS

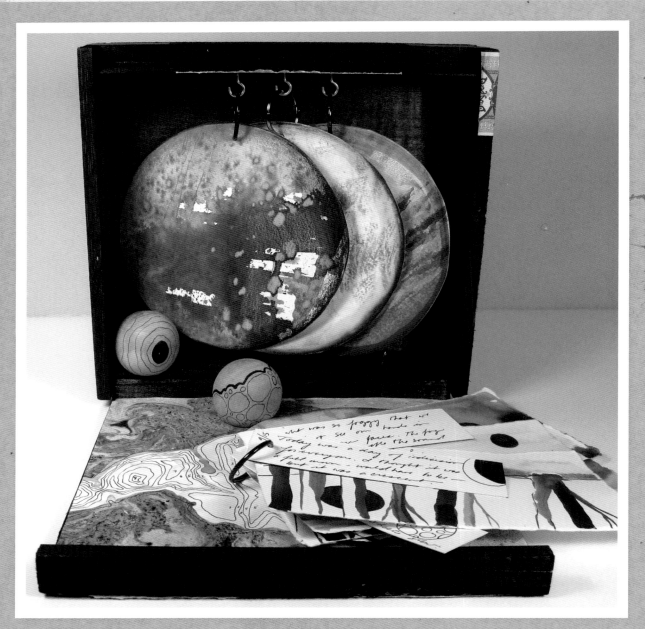

Cigar Box Journal

This square cigar box lent itself to the inclusion of the round moons. I have many paper moons this size that I doodle into when thinking about other things. They can be rearranged in the box, almost like a portable altar.

I also included text with poetic moon observances, a marbleized paper "map" of a lunar landscape and two small three-dimensional moons.

PAPER MOONS
Cigar box, watercolor, colored pencil, ink, wooden knobs, hardware

Receive downloadable bonus materials when you sign up for our free newsletter at artistsnetwork.com/Newsletter_Thanks.

Hooks Help Add Versatility

I used tiny brass eyehooks to hang the paper moons. The hooks are open, allowing me to swap the moons around or add others as I wish. They screwed into the box easily after I made little starter holes for them with a pushpin. The rings were purchased at an office supply store.

Mounting Things in Boxes

If you want to mount things in your box journal permanently, use glue such as Elvace or Jade glue (sometimes called PVA). These glues are typically used for bookbinding and are available at art supply stores. Avoid white school glue, carpenter's glue or hot glue as these will become brittle over time and your creation will fall apart.

You can also use hardware such as eyehooks, pins or wire to hang or bind objects into your box journal.

If you want your treasures to remain pristine, unsullied by glue and unpierced by drills or nails, your box could be made with dividers, or could hold a series of smaller boxes and envelopes in which your special objects are safely stored.

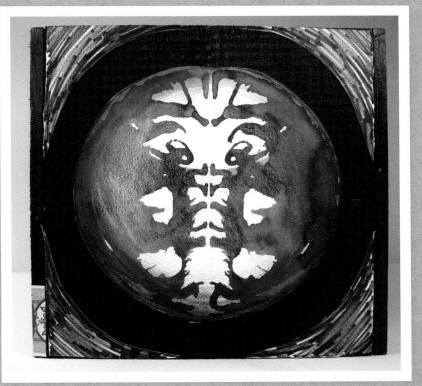

Cigar Box Journal Lid

I colored into an inkblot with colored pencils, cut it into a circle, and mounted it onto the lid of the box with Elvace glue.

Leather-Bound Cigar Box Journal

A friend gave me some cigar boxes, and I covered one of the them with a piece of soft leather. I cut the leather with a craft knife to fit the top and bottom of the box, leaving overhang to fit around the sides, and glued it with undiluted PVA. Before it was dry, I cut a slit in the leather on the box top and inserted a long strip into it for a closure. Then I cut the corners and butted them together. After the glue dried, I aged the leather by painting acrylic Raw Umber onto it and wiping it off with a damp cloth.

Cigar Box, Interior

The bird and nest with eggs were made using a gouache resist. I painted pale blue gouache on heavyweight printmaking paper everywhere I wanted light color to remain. Once that was dry, I painted India ink over the whole image and let it dry. Then I washed the paper under cool running water until the runoff was clear and the image appeared. The pieces were mounted into the bottom and lid of the cigar box with undiluted PVA.

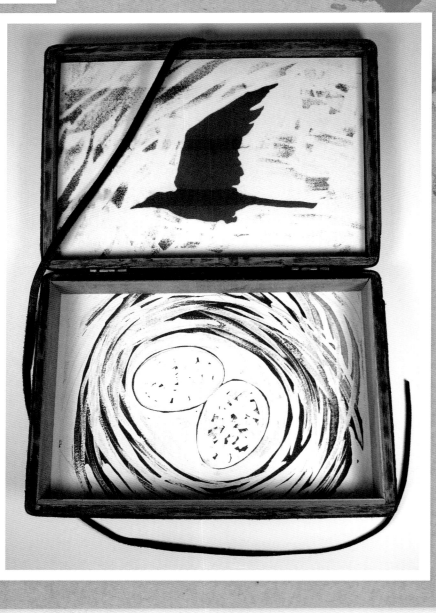

BIRD AND NEST
8" × 6" × 2" (20cm × 15cm × 5cm)
Cigar box, leather, acrylic paint, paper, gouache, India ink

Eyeball Tin Journal

I found this tin in a fancy spice store. It seemed full of possibilities—I could put a bunch of tiny scrolls in it, or rock "portraits," or tiny planets. In the end, I decided that it would make a fun container for washy, abstracted birds' eyes on a string. I may add text on the back of the eyes in future, and possibly add more eyes, too.

EYEBALL TIN, WORK IN PROGRESS
3" × 3" × 2" (8cm × 8cm × 5cm)
Metal tin, watercolor paper, watercolor, ink, ribbon

Eyeball Tin, Interior

I cut slits in the orbs on either side, wide enough to lace a ribbon through. The eyeballs are not glued or fixed on the ribbon, but can slide around and be rearranged.

CABINET OF CURIOSITIES

Beginning in the early 1600s in Europe, a trend of building cabinets of curiosities arose among wealthy scientists, naturalists and their patrons. There were entire rooms, often called wonder-rooms, in which objects and antiquities relating to natural history, geology, archeology and other scientific disciplines were displayed. These were the precursors to natural history museums, though they sometimes included fakes and fanciful objects, such as unicorn horns, mysterious reliquaries and spurious drawings of beasts that never were.

Smaller cases were also made and filled with objects and drawings to represent the whole universe in miniature scale: shells, bones, fossils, coral, insects, drawings, star maps and other wonders.

With box art journals, we can create our own miniature cosmos, filled with our own observations and flights of fancy. In a small, glass-front medicine cabinet with shelves, you can organize, classify, sketch and embellish a collection of meaningful objects as a wonderful kind of living journal—a tiny cabinet of curiosities. What if you had a stack of shadow boxes, all the same size, in which you arranged collections or drawings that could be viewed through a glass cover? There could be writings as well, and the removable back would allow you to have a changing exhibit of your natural or mysterious collections.

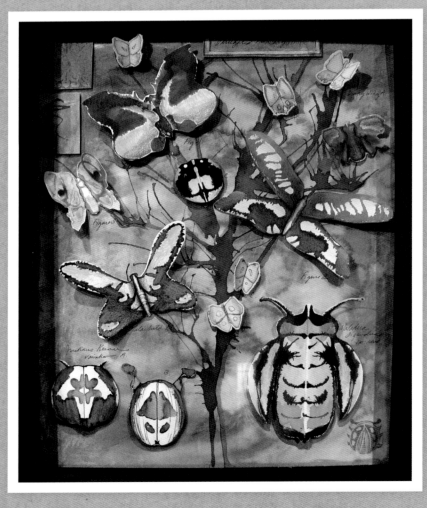

Shadow Box Art Journal

This shadow box is full of creatures made with ink and attached with glue to a blown-ink tree branch. In the grand tradition of cabinets of curiosities, all of my creatures are made up, with scientific-sounding names.

VARIEGATED FRITILLARY 2
Shadow box, Rives BFK, watercolor, silk, colored pencil, ink, rubber stamping, PVA, styrene

Make a Simple Tray Box

If you want to house objects of a particular size, or create a series of box journals that are all the same size, you can build a box to suit your own specific needs.

I learned much of the following process from my friend, the wonderful book artist and bookbinder, Barbara Mauriello. Her method for cutting paper to make perfect corners is especially useful—you'll see how nifty this is as you do it.

PART 1: CUTTING THE BOARDS TO SIZE

Use a tabletop cutter to cut the binders board. If you are very careful with your cutting and measuring, and are confident in your ability to cut a square corner, you can use a mat knife, steel ruler and steel square.

MATERIALS

2-inch (5cm) chip brush

½-inch (12mm) bright brush

.070" to 0.80" (1.8mm to 2mm) binder's board (1–2 half sheets)

bone folder

brick or box for shaping

decorative paper

heavy books for weight

metal straightedge

methyl cellulose

pencil

PVA glue

scissors

scrap paper

self-healing cutting mat

small brush

tabletop paper cutter (or mat knife)

wax paper

1 Measure and Cut the Boards

Determine the length (A) and width (B) of the bottom of the tray and the height (C) of the sides. Cut the binders board so that it is square on one corner. Don't trust that the purchased board is perfect—cut it to square yourself.

Mark the height of the sides (C) and cut two sides the same length (A) as the base. For the other sides, mark the height (C) again, but add two times the thickness of the board to the width (B) measurement. Cut two of these as well.

You should have a base, two sides the length of the base, and two sides the width of the base plus twice the thickness of the board.

PART 2: GLUING THE TRAY

Place a piece of wax paper on your work surface that is bigger than the base of your box by 2–3" (5–8cm) on all sides. This will keep your tray from sticking to the table. Find a substantial object, such as a brick or box, that has a side that is 90 degrees with your work surface.

1 Apply PVA to the Edge of the Length Side
With a small brush, apply undiluted PVA glue to the bottom face of one of the side pieces that are exactly as long as the base, as shown.

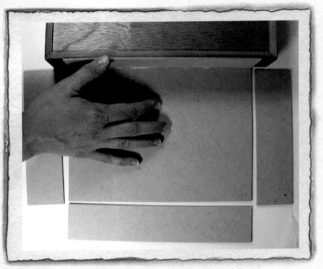

2 Secure the Side to the Base
Press the side to the base, using the box as a guide. Hold the side in place for a moment for the glue to set.

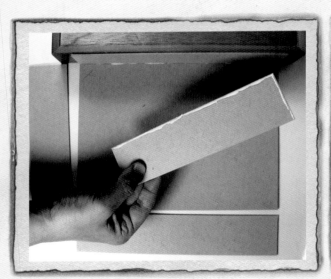

3 Apply PVA to Edges of the Width Side
Take a piece that is two-board thicknesses wider than the tray width, and with a small brush, apply diluted PVA glue to the bottom and side face of the board.

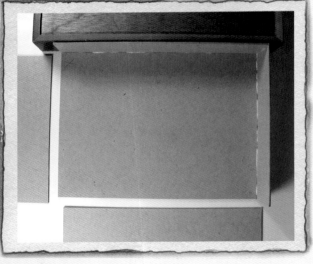

4 Secure the Side to the Base
Press this side to the base and the first side, still using the brick or box as a guide. You will see that this piece now extends one board thickness, awaiting the next side piece.

Receive downloadable bonus materials when you sign up for our free newsletter at artistsnetwork.com/Newsletter_Thanks.

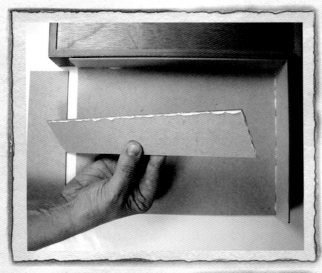

5 Place the Third Side
With a small brush, apply diluted PVA glue to the bottom face and side edge as shown. Press this into place.

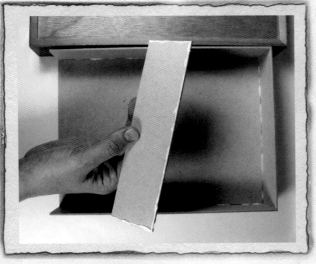

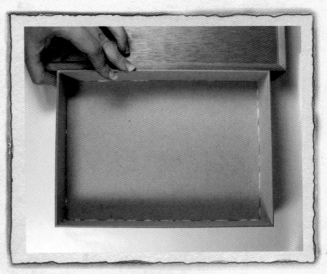

6 Place the Fourth Side
With a small brush, apply diluted PVA glue to the bottom and both sides on the face of the last side piece. Press the final side into place and hold for a moment.

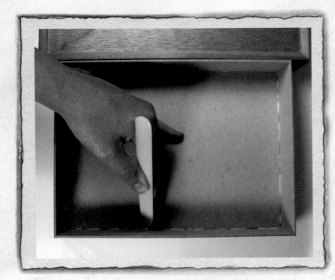

7 Clean Up
Use the tip of your bone folder to scrape off any excess glue.

Visit artistsnetwork.com/AlternativeArtJournals for a bonus demonstration by Margaret Peot.

PART 3: COVERING AND LINING THE TRAY

Mix methyl cellulose according to the instructions on the package. In another container, mix half methyl cellulose and half PVA. This will be the glue combo that you use to adhere the decorative paper to the tray.

You can cover your tray with decorative paper, such as marbleized paper or printed papers available at craft and art supply stores. For this tray box journal, I used antique newspaper from the late 1800s. These papers are available on eBay and at antique stores. Newsprint of this vintage is especially nice. It has a high rag content, so it does not yellow the way that modern pulp newsprint does. Also, you can see and feel the indentions of the metal type on the paper, which makes for a subtle but interesting texture.

1 Cut Paper for the Sides

Cover the sides of the tray first. Cut the width of the paper for the sides twice the depth of the tray plus 2" (5cm). Mark and cut the length of the paper about ¾–1" (19–25mm) wider on both sides.

2 Apply the Glue Mixture

Do the next series of the steps with a wet, gluey piece of paper; work quickly so that you won't have to reapply the glue. Use a chip brush to apply the glue mixture. Place your decorative paper on top of some scrap paper and begin brushing the glue mixture onto the back of the decorative paper. Start in the middle of the paper and brush out onto the scrap paper.

3 Place the Paper

Get rid of the gluey scrap paper and place the glued-up decorative paper on a clean scrap sheet.

Place the box on the decorative paper, so that 1" (2.5cm) extends below the base of the box.

4 Smooth and Clip

Smooth the paper over the ends and clip the corners at the base as shown.

Receive downloadable bonus materials when you sign up for our free newsletter at artistsnetwork.com/Newsletter_Thanks.

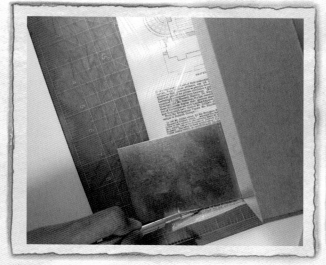

5 Cut to the Edge

Place the box on a self-healing cutting mat. Place a straightedge (this is a square-cornered piece of aluminum that I use for this purpose, but you can use a small metal square ruler) at the corner of the paper as shown. Make one cut from the corner of the box to the edge of the decorative paper.

6 Cut the Corner

Now, here's Barbara's nifty little cut for making neat corners: Move the straightedge in exactly the width of the board. Cut along the straightedge to the edge of the decorative paper about 1/8" (3mm) away from the box. Then make a tiny cut from the corner to the start of the first cut. Detach that tiny piece.

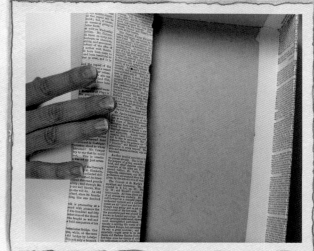

7 Cover the Inner Corners

Press the little edges into the box first, making sure they cover the inner corners.

8 Secure the Paper to the Inner Base

Fold this side over and down the inside of the box and onto the inner base. You must do this to two opposite sides. The image shows this step being done to the second side so you can see how to fold it over and what it looks like afterwards.

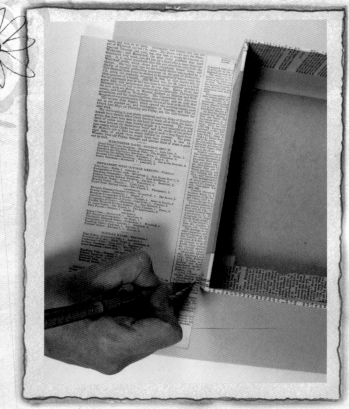

9 Mark and Cut Paper for the Remaining Sides

For the two remaining uncovered sides, mark and cut the paper a little less wide than the sides to be covered.

10 Apply the Glue Mixture

Once again, you need to work quickly so that you won't have to reapply the glue mixture. Use a chip brush to apply the glue. Place your decorative paper on top of some scrap paper and begin brushing the glue mixture onto the back of the decorative paper. Start in the middle of the paper and brush out onto the scrap paper. Fold and throw away the gluey scrap paper, and place the glued-up decorative paper on a clean scrap sheet. Place the box on the decorative paper, so that 1" (2.5cm) extends below the base of the box.

11 Smooth and Clip

Smooth the paper over the ends and clip the corners at the base.

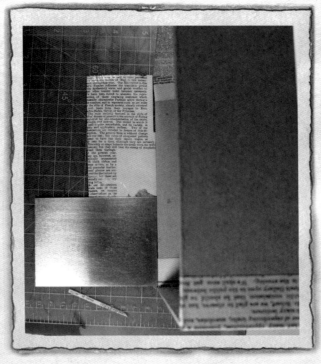

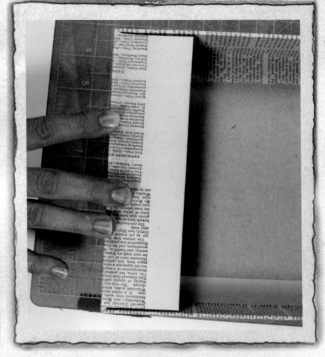

12 Cut to the Edge and Corner

Place the tray box on a self-healing cutting mat. Place the metal straightedge at the inner edge of the width of the board, as shown. About an $1/8''$ (2.5cm) away from the box, cut all the way to the edge of the decorative paper. Then make a tiny cut from the corner to the start of the first cut and detach that tiny piece.

13 Fold Over and Secure

Fold the paper over and press to secure it to the inner side of the box. Repeat this process for the remaining uncovered side.

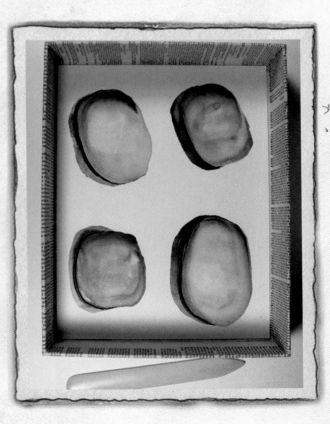

14 Glue In the Lining

You can use any decorative paper for the lining of your box. This is a painting I did of beach rocks and shadows. I cut it to slightly ($1/16''$ (2mm) of an inch on all sides) smaller on all sides than the inner dimensions of the tray, glued it with the glue mixture, and pressed it in with scrap paper and a bone folder.

PART FOUR: MAKING THE BASE AND LID

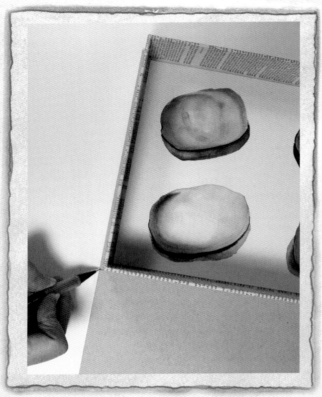

1 Cut the Board

Cut two pieces of board about ⅛" (3mm) bigger all around than the box.

2 Cover the Base and Lid

Cover the base and lid in the same manner. Cut your decorative paper about 1" (2.5cm) bigger all around than the board. Apply the glue mixture to the back side, remove your gluey scrap paper, and place the board in the middle of the decorative paper. Trim the corners and wrap the edges around to the back side of the board. Using a clean piece of scrap paper, smooth the decorative paper to the board face with a bone folder.

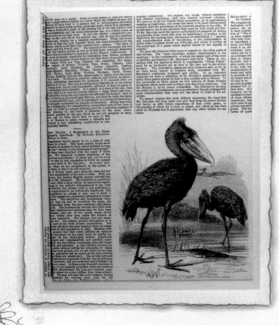

3 Make and Secure the Lid Liner

Cut a piece of board about 1/16" (2mm) smaller all the way around than the inside of the opening of your tray. Cover this piece of board with decorative paper, perhaps a contrasting sheet or with something interesting that will only be seen when the box is open. In this case I used this strange bird illustration from an antique paper.

Brush undiluted PVA on the back side of the liner, center it on the under side of the lid, and press it down. Cover this with a couple of clean pieces of scrap paper on top of a piece of wax paper, and weight it down with a couple of heavy books. Leave it under the weight overnight, changing the scrap sheets once.

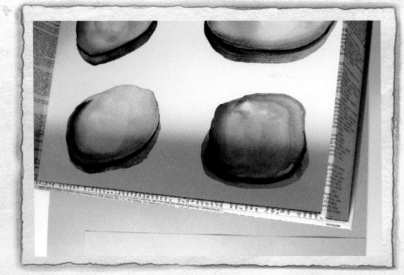

4 Attach the Tray to the Base

Brush undiluted PVA on the bottom of the tray. Center the tray on the back side of the covered base. (Remember, you want the exposed board to be hidden.) Hold this in place for a moment, then put a couple of heavy books on the top of the tray and leave it overnight.

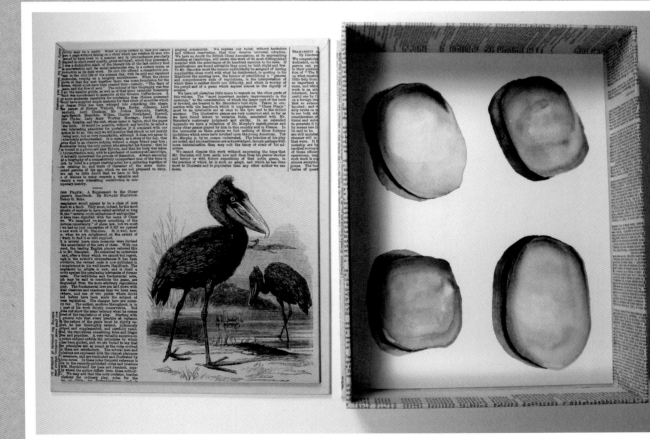

The End Result

The finished tray and lid await filling with beach stuff and notes from my stay at the Hermitage Artist Retreat.

VARIATIONS OF THE SIMPLE TRAY BOX

Once you know how to make a simple tray box, you can figure out how to make variations—add a hinged lid, dividers, even wheels.

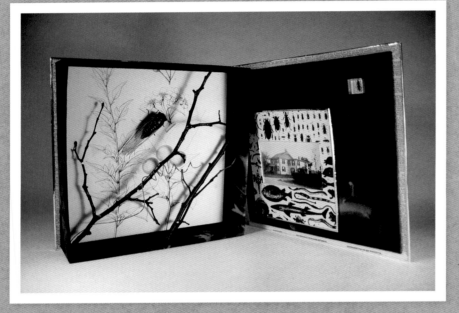

Cicada Box, Interior

This simple tray box journal was made with a toy cicada I found in Chinatown. I was inspired by a story my husband told me about a night when he was a boy, and a cicada got into the attic room he shared with his three brothers.

CICADA BOX
10" × 10" × 3" (25cm × 25cm × 8cm)
Book board, bleached viscose book cloth, antique papers, old photograph, silver wire, twigs, toy insect, Plexiglas, aluminum tape, wood and metal findings.

Cicada Box, Exterior

I used a Dremel tool to drill through the lid layers and the wooden egg, and screwed a flat-head screw through all of them. The screw head on the inside of the lid is hidden by the attached panel of bugs and photograph.

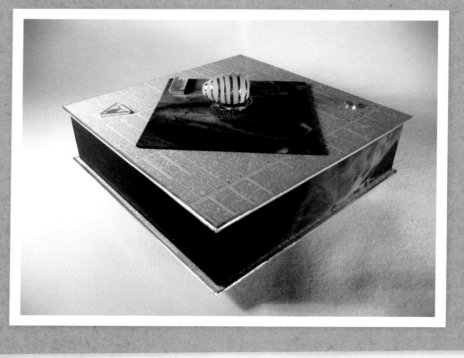

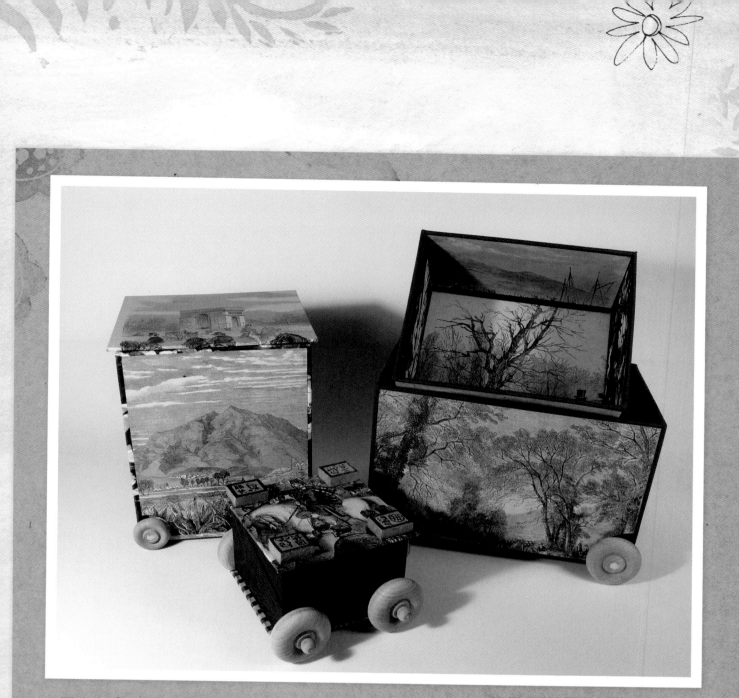

Think Outside the Box

After seeing an exhibition of antique circus memorabilia, I made these simple trays with wheels and decorated them with antique papers. I intend to cut windows into them and put dioramas within that show natural wonders (perhaps in the form of plastic animals), and further decorate them with other wondrous doodads.

LANDSCAPE TROLLEY
Four boxes ranging in size from
4" × 4" × 3" (10cm × 10cm × 8cm) to
8" × 5" × 5" (20cm × 13cm × 13cm)
Book board, book cloth, antique papers, marbleized and other decorative papers, wooden game pieces, dowels, wooden wheels

chapter seven
Faux Family Album
Art Journals

You are in an antique store. The air has a musty, old-book smell. In the clutter of Depression glass and junk jewelry, you find a shoebox full of old photographs. Who were these people? Stern men, women with Mona Lisa smiles, babies oblivious to the camera. There are homes, landscapes, family groups—all forgotten, all begging to have a story told in their honor.

The faux family album is a great tool for both writers and artists. You can also draw into the albums, of course. Draw family members, pets and scenery where you are missing them in your collection of photos.

In this chapter you will learn what kinds of sketchbooks are suitable for an album and where to find old photographs. You will also find some fun questions and prompts to get you started on your own faux family album art journal.

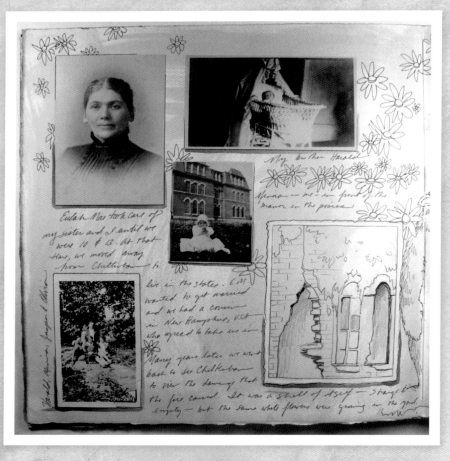

Art Journals Can Tell a Story

For these pages, I picked through my collection of old photographs until I began to see and feel associations between the people and places. I wrote down their story: A brother and sister made their way to North America to start a tourist lodge. I added a drawing where there needed to be one for the story and unified the pages with watercolor aging and sepia-ink drawing.

MINNA AND HARALD
Page size: 12" × 12" (30cm × 30cm)
Old photographs, Prismacolor sepia and black pens, double-sided tape, on watercolor-aged Rives BFK, bound into a coptic binding

Receive downloadable bonus materials when you sign up for our free newsletter at artistsnetwork.com/Newsletter_Thanks.

CHOOSING A BOOK FOR YOUR ALBUM

The key to picking a book for your album journal is to choose a book with a spine (the side of a book where the pages are joined together) that is wider than the fore edge (the side of the book where the pages open). If you look at any number of photo albums, you will notice that there has been thickness added to the spines in various ways. There is often the addition of a little metal or plastic edge on each photo page, an extra piece of paper inserted between each page, or each page may have been folded towards the spine.

If you add a lot of collaged materials to a traditionally bound book, you will end up with a book that is very bulgy and fat at the fore edge. Spiral bound sketchbooks, scrapbooking books and photo albums with paper pages are all suitable for use as an album journal. Coptic books and accordion books also work well for this purpose.

Folded Edges Create a Thicker Spine

This photo album was made thicker at the spine by folding the spine edges in about 1″ (2.5cm), and binding them together in a stack. That way, you can add photographs or other collage objects to the pages without making the fore edge of the book wider than the spine, as it would be if you did not have this thickness built into the spine of the album.

DISSECTING A PHOTO ALBUM

Taking apart a photo album will allow you to see how it is made and help you make one to suit your own specifications. Most photo albums are intended to be taken apart, with posts that unscrew or tabs that slide through metal clips, so that you can add additional pages. The following pictures detail the dissection of the *Dracula* album, so you can see the bones of it.

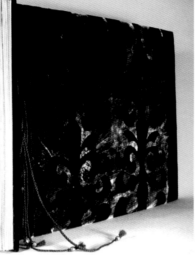

DRACULA ALBUM
12" × 16" × 1" (30cm × 41cm × 2.5cm)
Shibori dyed velvet, cotton batting, book board, decorative paper, Stonehenge paper, watercolor and ink

Dracula Deconstructed

This album was created to house a collection of letters from Jonathan Harker from Transylvania for a book project that a friend and I started based on Bram Stoker's *Dracula*. The project never came to fruition, but the album stuck around in all its decayed glory.

The Dracula album has a padded velvet cover, with grommets in the corners. The brass grommets have been colored with a black permanent marker to tone them down.

Receive downloadable bonus materials when you sign up for our free newsletter at artistsnetwork.com/Newsletter_Thanks.

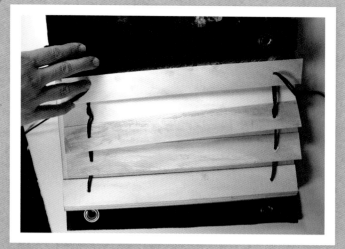

The Album Untied

Its essential components are pages with a folded piece at the spine, two holes punched in each page, and a hinged cover with grommeted holes that correspond with the holes in the pages. I stacked the folded pages and drilled through them with a hand drill with a large bit in it, though I'm not sure that I would do it this way today—perhaps a nice hole punch would do the trick.

Hinged and Covered With Velvet

The grommeted section is hinged to the cover with the velvet. If the hinge wasn't there, the book couldn't open.

There are two thin pieces of book board (that correspond to the thickness of the folded edges of the pages) and two cover-sized pieces of board covered with velvet. The cover-sized pieces of board are lined with marbleized paper.

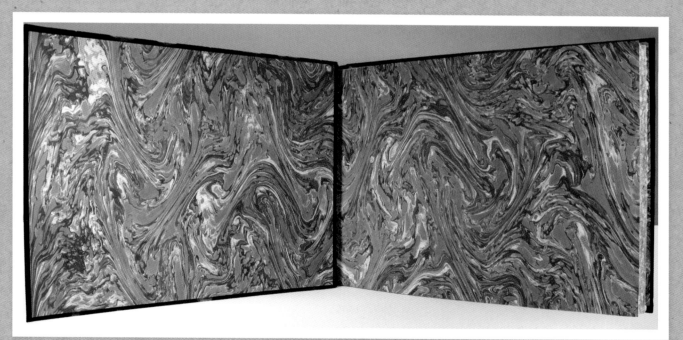

Lined Cover

The cover is lined with marbleized paper, as well as the first page of the album.

FINDING OLD PHOTOGRAPHS

Most antique stores will have boxes of old photographs to look through, but as they become more popular for use in scrapbooking and artwork, they have become more expensive, too. It used to be that you could spend five dollars and get a whole lot of them, but now they can be one to five dollars each.

Estate sales are also good places to find old photographs, as well as eBay, though the bidding can go up surprisingly high on collections of photos. Sometimes damaged images will sell for less. And pictures of houses and scenery are not as popular as the sepia-toned portraits, but they are no less valuable for this purpose.

Scan or color copy the old photographs on the following pages to use in your faux family album journal and add a little old-photo texture. If you don't use any actual photos but draw your own instead, take note of the different border styles used on old photographs.

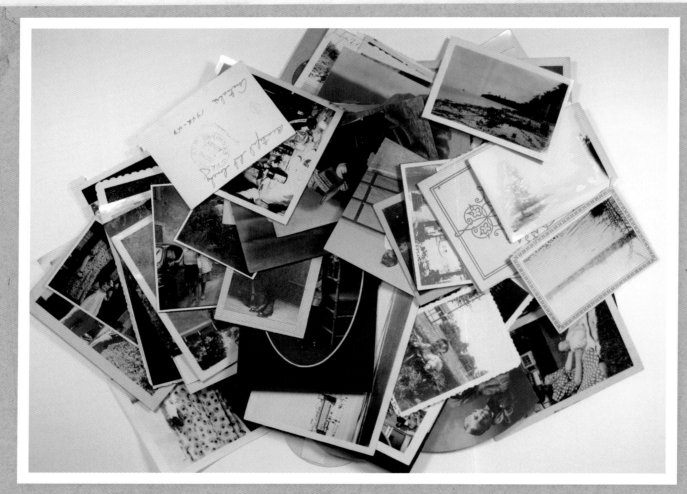

Use Your Own Family Photos

In a pinch, you can use your own family photos. Make copies of them, of course, or dip into the box of odd ones that didn't make it into your real family album. If you have some friends who are also interested in creating a faux family album, see if you can trade some of your family photos for theirs—it might be easier to make up stories about people who are not your real relatives.

Ma & Pa's House (1925)

YOUR FAUX FAMILY ALBUM

Photo albums record alliances, events, holidays and relationships between family, friends and colleagues. Sometimes the record in front of us is an honest account of what transpired, and sometimes we find ourselves very aware of the machinations of the person who accumulated and arranged the photographs. An album can truthfully record an event, or show only what we are meant to see and none of the underlying family conflict.

The album you create as an art journal is a place for you to explore ideas and stories, imagery and fantasy. Your album journal does not have to cling too tightly to reality. In fact, you can take wild leaps away from the real world. Does an alien come to live with the people depicted in the photographs? Does something magical happen to them? Is one of them on the lam from the law? What happens?

You Will Need:

- acid-free pen
- brush (optional)
- colored pencils (optional)
- old photographs
- photo album
- photo corners (optional)
- scrapbooking tape (archival or acid-free)
- watercolors (optional)

Use a Combination of Photos and Drawings

Use real photos and leave spaces for text or places where you can draw in or paint your own images to accompany them.

FAMILY ALBUM ART JOURNAL
12" × 12" (30cm × 30cm)
Old photographs, Prismacolor sepia and black pens, double-sided tape, on watercolor-aged Rives BFK, bound into a coptic binding

Receive downloadable bonus materials when you sign up for our free newsletter at artistsnetwork.com/Newsletter_Thanks.

The handwritten notes in the image read:

Fordham — The Hermitage House, home of the preeminent monster collectors.

Saranac Lake; Hermitage House

Alfred was designed in early cat lungs. He is nearly a magical octopus

Alfred

Bessie is four years old in this picture. She is accustomed to salt water but has adjusted to fresh.

Nothing in Punkin known of Punkin...

Bessie

The Fordhams have helped and collected sea creatures since the 1920's.

The residents of Hermitage House, Otto, Jeffrey and Emma Fordham

Punkin

Tell an Imaginative Family Story

Your faux family album can be quite fanciful. These pages tell the story of a trio who become the caretakers of a host of Loch Ness-style sea monsters. Your album journal is as unlimited as your imagination.

THE OCTOPUS COMES TO THE LAKE HOUSE
12" × 12" (30cm × 30cm)
Old photographs, Prismacolor sepia and black pens, double-sided tape, on watercolor-aged Rives BFK, bound into a coptic binding

Aging the Page

You might consider aging the pages of your faux family album if you are using old photos. It provides a richness and can unify the look of your art journal. You can use watercolor, ink or thinned acrylics to do this. Let the pages dry thoroughly before adding photos or other collage materials.

EXERCISES IN INSPIRATION

The following exercises may help you start to see associations, spin stories and get started with your own album art journal. Use these photos, or ask yourself the same questions about photographs in your own collection.

What Happens Next?

Here are stages of the life of a girl turned young woman. What is the next step in this series? An old woman? A middle-aged woman with a family? A glamorous, successful author? Draw or write about the next step in this person's life.

Turn Around—What Do You See?

A gorgeous scene—but what is behind the viewer? Another similarly gorgeous scene? A bear? A family camp site with two tent pegs too few and a fuming father? Draw or write about what is behind you.

Who Took This Picture?

The young man leans his arm along the back of the seat, looking at the person taking the photograph. Is he leaving on a trip? Did he just get a new car? Is the wave an invitation to the photographer or a goodbye? Draw or write about the picture he sees.

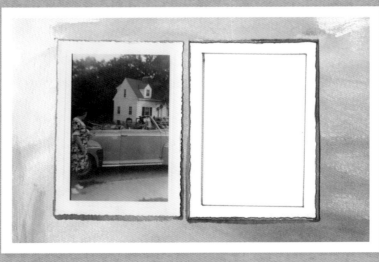

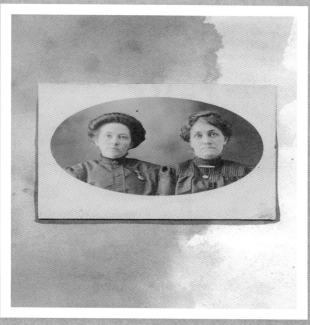

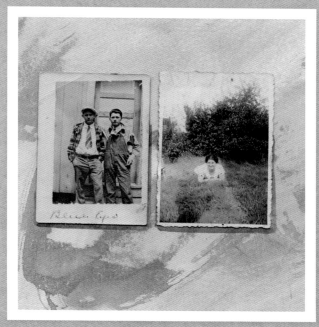

Who Are They?

Are they sisters? Teachers? Friends? Enemies? Do they like each other? What are they thinking? How did they come to be photographed? Was it a scheduled portrait, or did they duck into a portraitist's shop on a whim? Did they quarrel about the price? Write about these women, or another mystery pair in your own photo collection.

Write the Relationship #1

Using these photographs, or two picked semi-randomly from your own collection, describe the relationship between these people. Are they siblings separated at birth? Star-crossed lovers? Do they share a secret? Or are they people living parallel lives on opposite sides of the globe?

Write the Relationship #2

Using these photographs, or three photos picked semi-randomly from your own collection, describe the relationship between these people. You can do this for any number of people, and it is good practice for making a whole host of relationships between people.

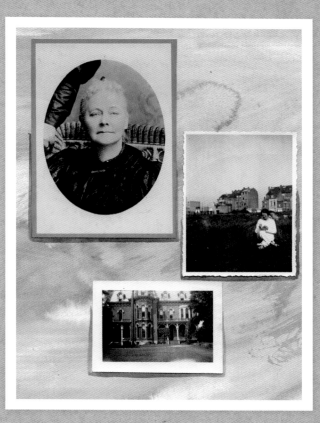

PICTURES OF NOTHING

While antique photographs are getting more dear, old pictures of "nothing" are often inexpensive as they are hard for dealers to classify or sell. These pictures are some of the most evocative images there are. Try to find them—an empty chair, a cloudy sky, winter branches—are wonderful pictures with which to daydream. (Why were they taken?) They are also nice to paint and draw into, or cut up for collage.

Cloudy Skies, Broad Vistas, Faded Landscapes

Someone turned their camera at these scenes and took a picture. What made them special to the viewer? These pictures can bring up a mood or memory, even though they don't seem to have a subject. This quality makes them great to use in a faux family album.

Australia

This is a particularly wonderful picture of nothing. On the back it says, "Australia—It's awfully lonely here. 1943." It is stamped with a round stamp stating it had been passed by the army review board.

Time and Again

There are lots of clues for determining when a photograph was taken. If you see poodle skirts, you might be in the '50s, big shoulder pads might put you in the '80s. Cars in a street scene (or no cars), or whether the picture is black and white can also define time and place.

This is wonderful if you are a historian, but it can stymie your fun if you are making a faux family album. You might see a young modern girl who you want to place with a Victorian-era matriarch, or a contemporary young farmer whom you can envision at the Vatican at the turn of the twentieth century. For the purposes of your album journal, suspend your common sense and put whomever you wish to together. Don't forget that your album is your creative endeavor for the purposes of generating ideas and having fun. It is not subject to the scrutiny of an era-control board!

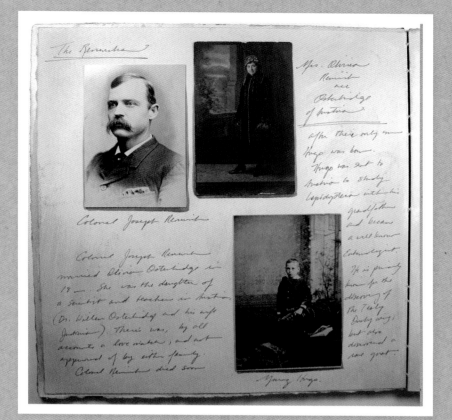

Use Additional Elements to Help Tell the Story

The inkblot butterflies make colorful additions to this album. These pages tell the story of a famous naturalist, but yours could tell about an athlete, musician, artist or traveler. You could include fake newspaper clippings, music paper, artwork and sketches.

HUGO RENWICK, FAMOUS NATURALIST
12" × 12" (30cm × 30cm)
Old photographs, Prismacolor sepia and black pens, double-sided tape, inkblots (India ink, Prismacolor pencils) on watercolor-aged Rives BFK, bound into a coptic binding

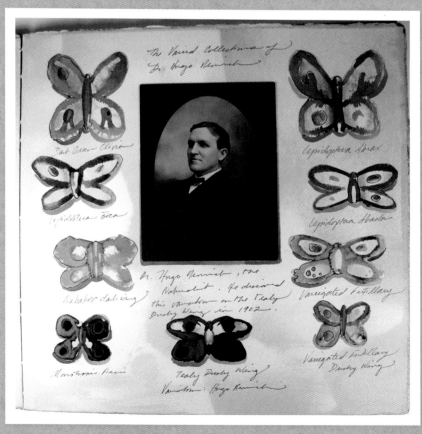

THE REAL FAMILY ALBUM

The line between some types of art journaling and scrapbooking can be fuzzy. There's something about the addition of personal photographs and factual narrative that starts to take an art journal out of the realm of art and more towards photo journaling. However, if you are inspired by an event in your life, and you get ideas about expanding or continuing in the same vein as you work, then why not work with real photos and real events? Think of your art journal as a work of creative non-fiction.

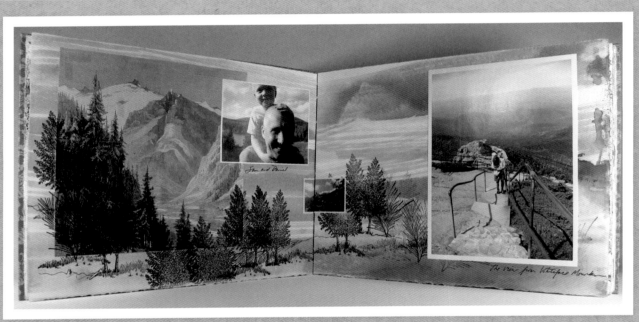

ADIRONDACK TRIP
12" × 16" (30cm × 41 cm)
Coptic-bound sketchbook (binders board, book cloth, linen thread, Elvace, methyl cellulose, Rives BFK), photos, rubber stamps, ink, colored pencil, watercolor, antique papers

Adirondack Trip, Interior

This was a scrapbook journal I made of a trip we took to the Adirondacks when my son was a baby. I include it because it is more art and text that photos—more of a personal impression of what it was to be there, rather than a factual step-by-step account.

Adirondack Trip, Cover

I used the Coptic-binding technique to bind this album so that I could age and paint the papers before I put them in the book and be in control of the book's shape. I also wanted to use this lovely brocaded book cloth.

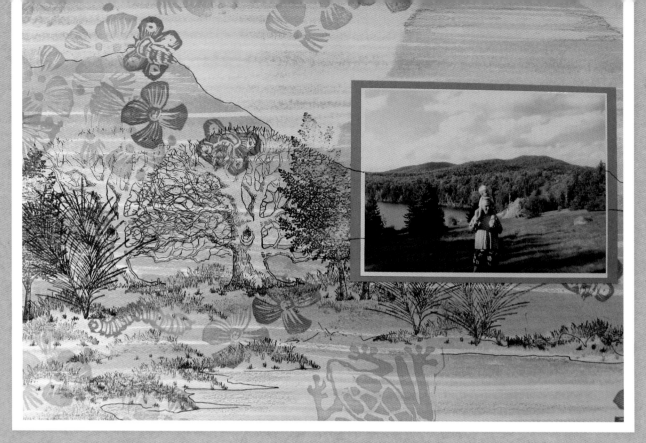

Adirondack Trip, Detail

I used watercolor, rubber stamps that I purchased and some I carved myself, colored papers and ink drawing to wed the photos with the background.

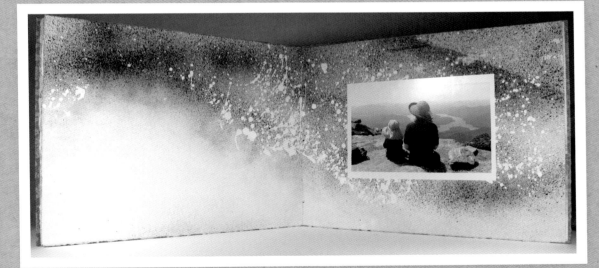

Adirondack Trip, Detail

This is the final page of the photo album. I sprayed watered-down black acrylic on these pages and spattered white on top to convey the rough texture of the stones where my little son and I sat, and to hint at further mountains to climb.

chapter eight
Tag and Charm
Art Journals

If you find yourself drawing on bits of this and that, making lots of small round paintings and cutting them out, or writing significant thoughts on beautiful scraps of paper, you might consider a tag or charm structure as a way to collect your creative thoughts into a journal form. If you love the way laundry looks flapping on the line, or you like to organize your ideas by hanging them up and arranging and rearranging the order, you might consider hanging your art journal bits on a line or a ring. The best thing about tag and charm structures is that you can work on disparate bits away from your studio, with your portable art kit, and bring them home to put them together.

In this chapter, we will explore tags to purchase and make, and hardware and connecting materials to help hang your charm journal together and keep it protected. Tag and charm journals, like box journals or card set journals, are perfect for artists who are uncomfortable with the linear quality of a traditional sketchbook.

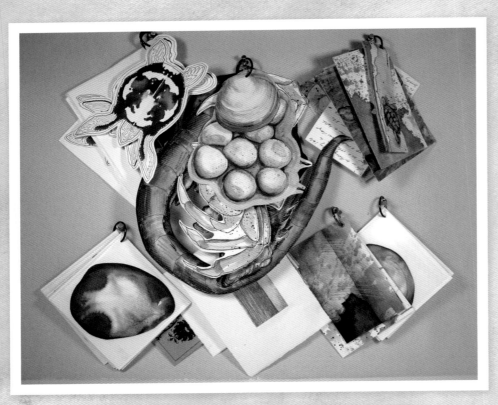

A VARIETY OF TAG JOURNALS
Paper, ink, colored pencil, metal rings

TAG JOURNALS

You can buy tags at most office supply stores. There are round ones with metal edges, manila-colored cardstock with strings attached and larger tags with places to write. You can make your own tags in whatever shape you wish and make holes in them with a hole punch.

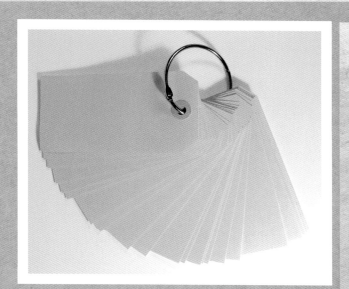

Alternative Book Structure

This handful of manila tags on a ring is a kind of book structure—the spine is where the holes are joined by the metal ring.

Containers for Tag Journals

Tags can be put on rings and be hung from a nail on the wall in your studio. But if you want to keep your tag journal dust free, you will have to make or find a container for it. Drawstring brocade bags work well for small tag journals. For larger ones, use a blank canvas tote with a flap that covers the top. You could also decorate an unfinished wooden box and put a hook or peg inside on which you could hang your tag journal. Boxes are particularly nice for storing art journals because you can put them on a shelf along with your other, more traditional sketchbooks.

Autumn Inspiration

One autumn, the leaves lay on the ground, and I was passing into a kind of hibernation time myself. I made these leaves by cutting them out with shaped-edge scissors. Then I drew and wrote on them and stored them in this repurposed cigar box.

FALLEN LEAVES
Manila tags, metal ring, colored pencil, watercolor, ink, Rives BFK, cedar cigar box

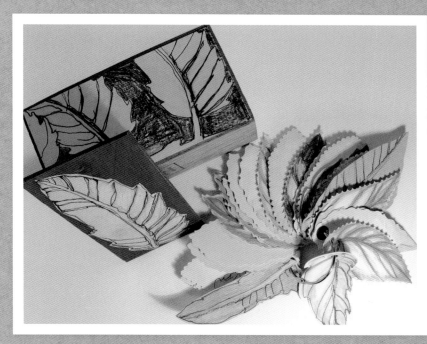

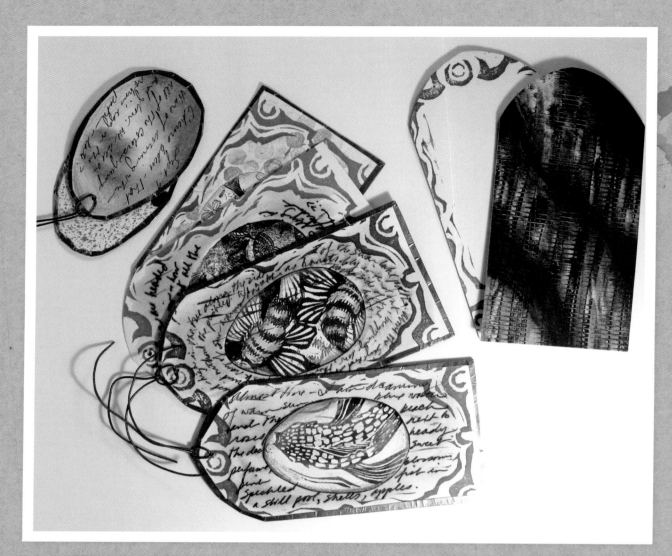

A COLLECTION OF JOURNAL TAGS
Rives BFK, ink, rubber stamping, colored pencil, paste paper, marbleized paper, copper foil tape, leather cord

Portable Tags

I worked on these egg-themed tags when my son was small, and I didn't have much extended time in my studio to work. I cut the tags to the two sizes I wanted, decorated them with a uniform rubber-stamp border, and carried them around as blanks to be filled in whenever I had a moment.

Reinforcing Tag Holes

If the paper you use to make your tag is sturdy enough, you do not have to reinforce the hole. However, if you wish, you can do so by gluing another piece of paper onto the tag and punching through both layers, or putting in a small grommet.

Receive downloadable bonus materials when you sign up for our free newsletter at artistsnetwork.com/Newsletter_Thanks.

UNIFYING YOUR TAG JOURNAL

Your tag journal can be a collection of totally disparate things, or can be unified by subject matter, color or shape of tags. Your tag journal could be all drawings of rocks, leaves, eggs or birds, or all of the tags could be shades of red. You might have tags that are all round, triangular, edged in gold or decorated with heat transfer foil. How you make your tag journal into a "set" is up to you, and the options are endless.

If you are drawn to this technique, then you probably already have an idea of what objects you would like to combine to make your own tag journal. And what you choose to combine will determine what materials and methods you use to combine things.

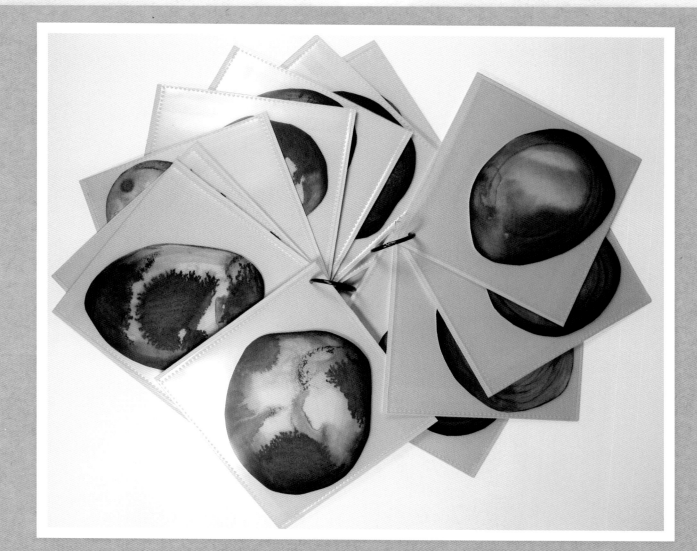

Objects Can Unify a Tag Art Journal

These rock portraits have been painted, shaded, cut out and preserved in CD sleeves because I couldn't bear to punch a hole in them—it would have destroyed the illusion.

APPALOOSA STONES
6" x 6" (15cm x 15cm)
Watercolor, ink, and colored pencil on hot-pressed Rives BFK watercolor paper, self-adhesive CD sleeves, metal ring

tag it
Create Appaloosa Stone Tags

Many people collect rocks or stones. Some have boxes and boxes of them that are unified by a common trait—striped, flat and smooth or spotted. However, painting rock "portraits" can be as satisfying as collecting the real (and heavy) things, and a collection of these can make an unusual tag art journal. Follow the steps to create Appaloosa, or spotted stones.

MATERIALS

½-inch (12mm) flat brush

black fine-point archival pen

colored pencils (cool gray, brown, warm gray)

India ink (in a squeeze bottle)

Rives BFK hot-pressed watercolor paper

small round brush

scissors

water

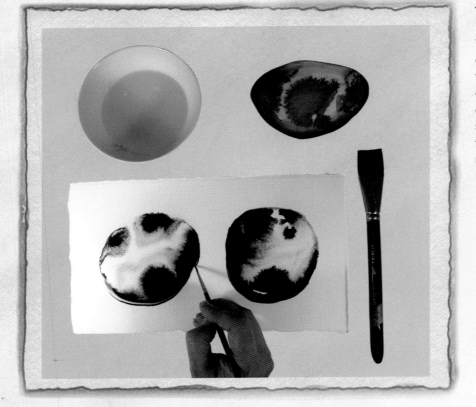

1 Start With Water and India Ink

With a ½-inch (12mm) flat, apply one or two rock-sized pools of water to the paper surface. Drip one to three drops of India ink into each puddle of water. The ink will spread into the water but not past the edges of the pool. Use a small round brush to clean up the edges. Let it dry.

Receive downloadable bonus materials when you sign up for our free newsletter at artistsnetwork.com/Newsletter_Thanks.

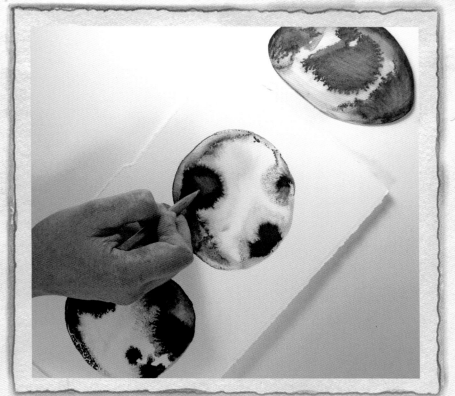

2 Shade the Spots

With a cool gray or brown colored pencil, shade the spots on your stone. This will keep them from looking too much like black holes.

3 Define the Stone's Edge

Using a fine-point archival pen, make a thin black line where your shadow is to define the edge of the stone.

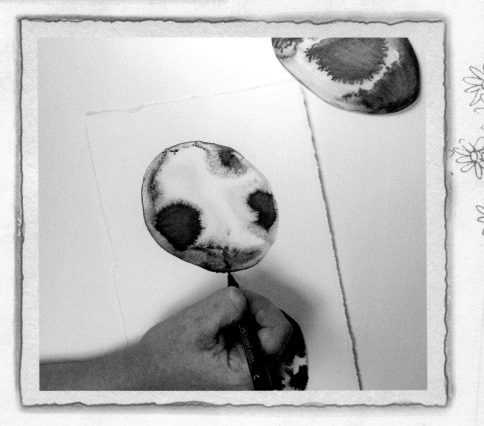

4 Shade the Edges

Use a cool gray colored pencil to shade the edges of your stone.

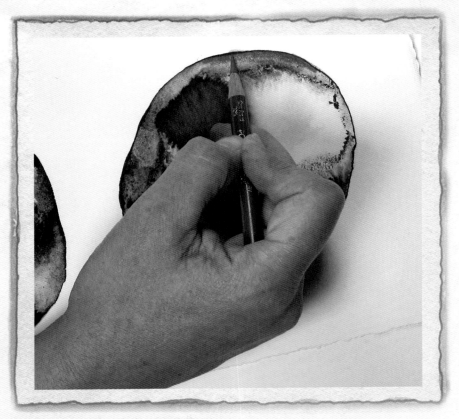

5 Blend the Tones

Use a warm gray colored pencil to blend the dark gray tones into the warmth of the extended India ink.

Cut out your rocks with scissors.

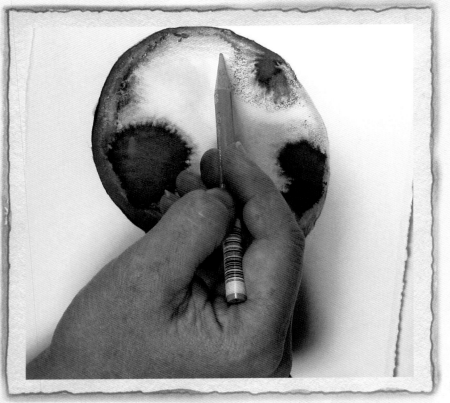

Receive downloadable bonus materials when you sign up for our free newsletter at artistsnetwork.com/Newsletter_Thanks.

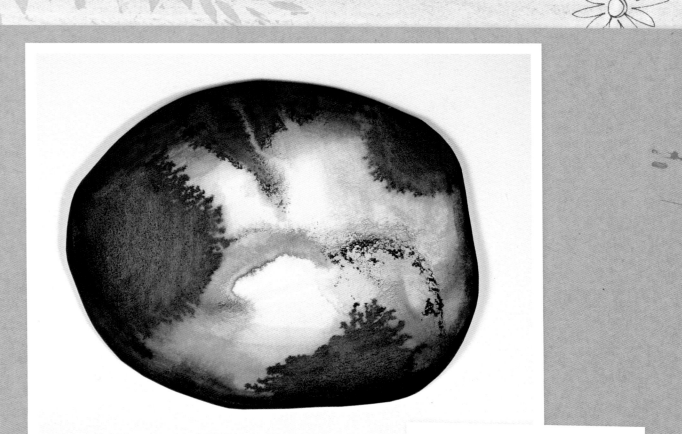

Texture and Shading Add Interest

The India ink and water puddles dry to make interesting, stone-like textures. Shading around the edge of the rock with colored pencils gives a feeling of dimension.

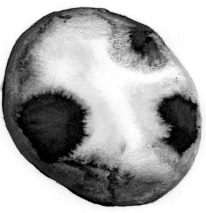

APPALOOSA STONES
3" x 3.5" (8cm x 9cm)
*Watercolor paper, India ink,
ink pen, colored pencil*

tag it
Create Realistic Stone Tags

The Appaloosa stones are extremely fanciful, but you can make rock portraits that are closer to the real thing. This technique is slightly different from the Appaloosa stone demonstration. I came up with it while trying to paint some round river rocks I collected, and it seems to work on many types of round eroded stones, like beach stones.

MATERIALS

½-inch (12mm) flat brush

black fine-point archival pen

colored pencils (black, medium gray, white)

India ink

Rives BFK hot-pressed watercolor paper
scissors

small round brush

water

1 Create Water Pools
With the ½-inch (12mm) flat, make one or two rock-shaped pools of water on the watercolor paper.

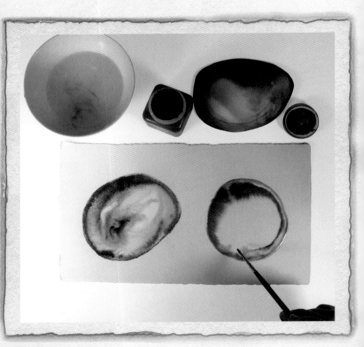

2 Add India Ink
With a small round brush, add a tiny bit of India ink around the edge of the pool. Allow this to dry.

Receive downloadable bonus materials when you sign up for our free newsletter at artistsnetwork.com/Newsletter_Thanks.

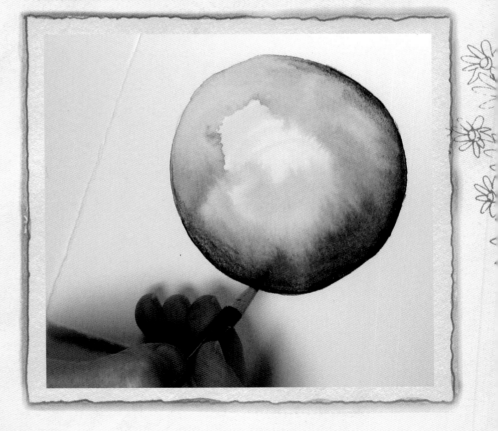

3 Define the Stone's Edge
With a fine-point archival pen, add a thin black line almost all the way around the stone to define its edge. The area you have not added a line to will be where your light source is coming from. This will help add to the illusion of roundness.

4 Add Shadow
Use a black colored pencil to add a deep shadow almost all the way around your rock, following along the black pen line.

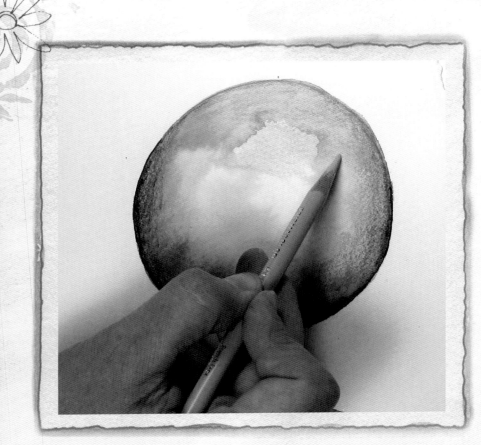

5 Define the Curve of the Rock

Use a medium gray colored pencil to define the curve of the rock, working from the outside edge inward.

6 Finish With Linear Detail

Add linear detail with sharp black and white colored pencils.

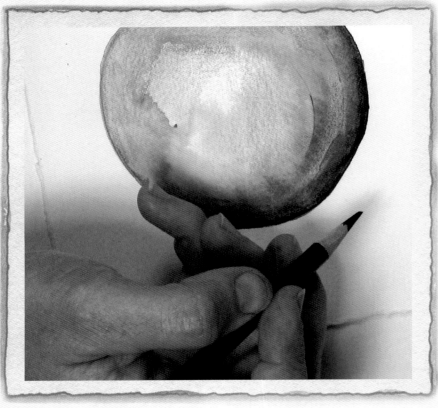

Receive downloadable bonus materials when you sign up for our free newsletter at artistsnetwork.com/Newsletter_Thanks.

Make Sleeves to Bind Your Rocks Onto a Ring

Cut paper (either the same watercolor paper or cardstock) to the size of the CD sleeves. Adhere the paper to the sleeves and slip your rocks in. (Make sure they are completely dry first!) Punch holes in the top corner of the squares and slip a metal ring in the holes. You can write or draw on the paper that holds the sleeve, telling where you "found" the stone, if it has magical properties, or is from another planet altogether.

Enhance Your Rock Portrait

A rock is indeed an axis mundi, a still point in a turning world. When you hold a rock in your hand, you are holding the ultimate stillness and antiquity. Now that you have made a paper rock, what can you write on it about this? How can you use the angle of your writing to enhance the trompe l'oeil?

AXIS MUNDI
3" × 3.5" (8cm × 9cm)
Watercolor paper, India ink, colored pencil, ink pen

EVENT TAGS

You can use tag journals to record an event with writing and images. Tag journals can be perfect if you have a collection of inspirational moments, but none takes precedence over another. The round ring acts as an infinite circle with no beginning or end.

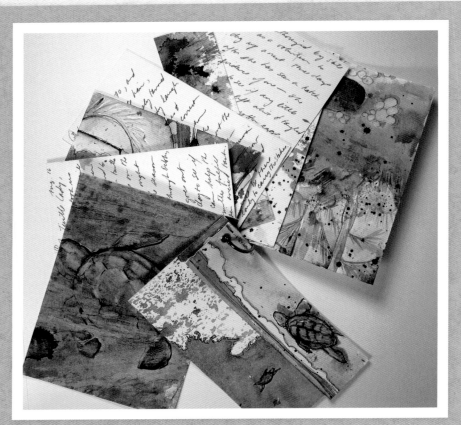

Use Photo Reference for Event Journals

I took pictures during a walk on the beach with the Turtle Patrol, then rushed back to the studio, made some notes about what we had seen and done, and made some tiny paintings based on the photographs.

WALKING WITH MAGGIE THE TURTLE PATROL LADY
6" × 8" (15cm × 20cm)
Colored pencil on Rives BFK paper, watercolor paints, ink, copper grommets, metal ring

Portraits of a Place

This is a stacked portrait of things I gathered while on an artist retreat. I couldn't take the real iguana home with me—but I could draw him.

BEASTS OF THE HERMITAGE
10" × 12" (25cm × 30cm)
Colored pencil on cold-pressed watercolor paper, watercolor paints, watercolor pencils, ink, metal ring

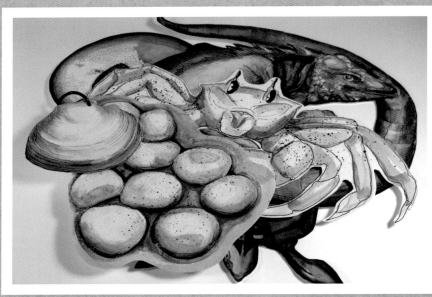

Receive downloadable bonus materials when you sign up for our free newsletter at artistsnetwork.com/Newsletter_Thanks.

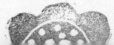

ALPHABET TAGS

Create light-hearted tags for a journal arranged loosely around the confines of the alphabet. You can use this form to arrange other stories as well—Wallace Stevens' "Thirteen Ways of Looking at Blackbirds," for example, or a darker alphabet like Edward Gorey's *Amphigorey*.

Alphabet Tag Art Journal

This is a fun journal to make in conjunction with a youngster. The cards were cut to size with rounded corners. I made a design on one side of each card with a sheet of alphabet stencils purchased from a hardware store. I spattered the ABC side with bright ink and a chip brush, and used the stencils as a guide for colored-pencil letters. Then I glued on photographs and inkjet-printed text.

MONTAUK ALPHABET
5" × 6" × 1" (13cm x 15cm x 3cm)
Book board, book cloth, acrylic ink, bristol board, colored pencil, inkjet-printed text, grommets, photographs, metal ball chain

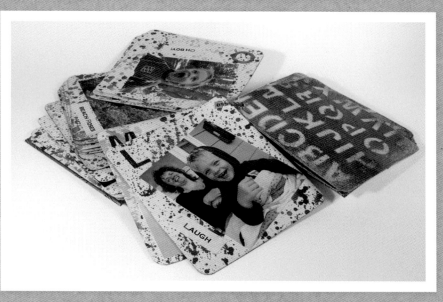

CHARM JOURNALS

If you would like to go way beyond the traditional sketchbook, how about an art journal you can actually wear? You would have to make your images a little more durable, of course. A paper necklace might be safe on a fine day, but if it even sprinkled, you would have a very soggy ornament. At some craft or art supply stores, you can buy small metal frames that are intended to put art in to be worn as a pendant. You can also make the paper durable by layering your drawings or writings between small pieces of Plexiglas, then binding the edges with aluminum or copper tape.

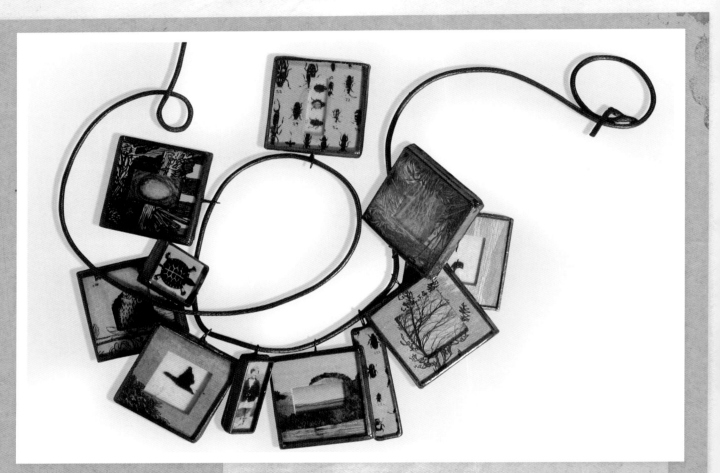

Wearable Art

These wearable art journals can function simply as a bit of fun fashion, or you could take them to a different level, making wearable artworks—belts, protective amulets, even chain mail.

Alternative Ways to Hang and View Tag and Charm Journals

Tags and charms can be worn as jewelry or they can adorn clothing—imagine a vest or jacket overlaid with charms and tags like scales or armor. Or try hanging tags on a line like laundry. A string of tags or charms can represent a chain of blessings, like prayer beads, or prayer flags. You could also bring a tree branch inside, cut one end cleanly to screw to a flat panel that can act as a base or be hung on a wall, and then hang tags and charms from it like leaves, flowers, insects or fruit.

Receive downloadable bonus materials when you sign up for our free newsletter at artistsnetwork.com/Newsletter_Thanks.

a charmed life
Make a Charm

Follow these steps to make a charm. The charm in this demonstration is about 2½" square (6cm), but you can make charms of any size or scale. To determine the size and shape of your charm, begin with the materials you wish to use. Do you have a series of long, thin drawings? Some squares of text? A series of amulet-like protectors? Let that be the guide, instead of forcing an incompatible shape onto your materials. You can sometimes purchase round pieces of clear plastic (as well as other shapes) at craft stores, but you can't cut a curved edge with the plastic cutter.

MATERIALS

½-inch (12mm) copper or aluminum tape

⅛-inch (3mm) Plexiglas or styrene

book cloth (optional)

bone folder

craft knife

decorative paper

double-sided tape

fine-point Sharpie

metal straightedge

methyl cellulose

museum board

pencil

plastic cutter

PVA glue

scissors

scrap paper

self-healing cutting mat

small brush

tiny drawing

1 Make a Glue Mixture and Cut the Boards

Mix the methyl cellulose according to the package directions. Take half of the methyl cellulose mixture and mix with an equal amount of PVA to make a glue combination of a suitable wetness for this project.

With an craft knife and a metal straightedge, cut two pieces of museum board to the same size. Measure and cut a hole in one of the museum board pieces that is the correct size to frame your small drawing or other artwork.

Cut a piece of decorative paper (in this case, antique newspaper) to cover the mat. Be sure to leave extra paper extending beyond the edges of the museum board.

2 Apply Glue

Paint the glue mixture onto the back side of the decorative paper.

3 Trim the Corners

Trim off the corners of the decorative paper. Work quickly so that you won't need to reapply more glue.

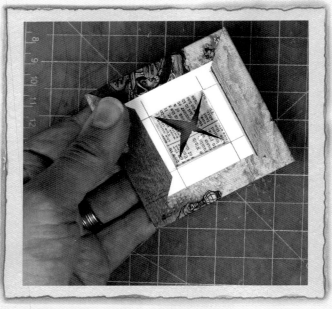

4 Secure the Border and Cut the Window

Fold the glued border to the back of the mat. With an craft knife on a self-healing cutting mat, cut an X in the window of the mat. Fold those pieces to the back of the mat.

Receive downloadable bonus materials when you sign up for our free newsletter at artistsnetwork.com/Newsletter_Thanks.

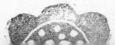

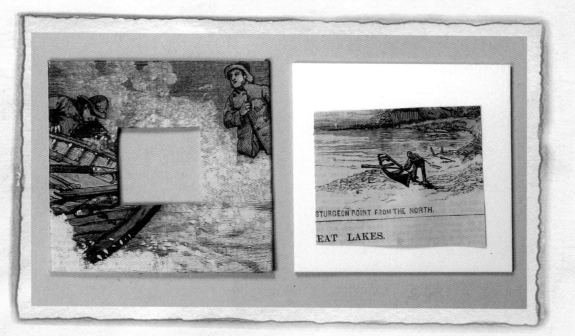

5 Place the Image

Cut your small image out, making sure to leave some extra paper around it. If you are making a small drawing, leave extra paper around the edge of the image. Center this under the mat window and affix it to the backing board with double-sided tape.

6 Attach the Mat to the Backing Board

Attach the mat to the backing board with double-sided tape. You can leave the backing board plain on the back, or use the glue mixture to affix another piece of decorative paper or a small piece of book cloth on the back.

7 Measure and Score the Plastic

The plastic used for this purpose will be covered on both sides with thin plastic to protect it from scratching. Leave this on while you mark and cut.

Mark the size of your museum board mat on the plastic. Lay the metal straightedge on the lines, and draw the pointed end of the plastic cutter towards you. Repeat six to eight times, scoring the plastic. Do not cut all the way through. If you are using $\frac{1}{16}$" (2mm) thick plastic, you might only have to score it four to five times. (Warning: This makes a spectacularly shrill noise!)

8 Cut the Plastic

Put the scored edge on the edge of a table or other surface with a straightedge and a 90 degree corner. Press down on the plastic and it should snap easily along the scored line.

When you have completed both cuts, peel the plastic film off and wipe any fingerprints off the side that will be face down on the mat.

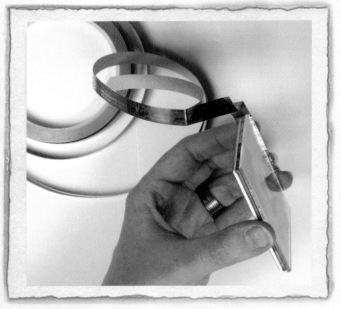

9 Wrap the Copper Tape

Release some of the backing from the copper tape. Place it on the edge of your mat-and-plastic sandwich in the middle of one of the sides. Wrap the copper tape all the way around, overlapping a little at the beginning.

Receive downloadable bonus materials when you sign up for our free newsletter at artistsnetwork.com/Newsletter_Thanks.

10 Secure the Copper Tape

Using a bone folder, carefully press the copper down on the front. The edges of the copper are very sharp, so take care not to cut yourself doing this. Then use a bone folder to press the copper down on the backside of the mat. As you can see here, the back is covered with a small piece of book cloth, but if you want to leave the white or black of the museum board that is fine, too.

Experiment With Different Materials

This charm is about 2½" square (6cm), but your charm can be any size or scale. Here I used images from antique papers, but I have also used decorative papers for mats for tiny drawings or paintings, as well as handwritten or decorated mats as a frame for a drawing.

RESCUERS
2½" × 2½" (6cm × 6cm)
Museum board, antique papers, book cloth, copper tape

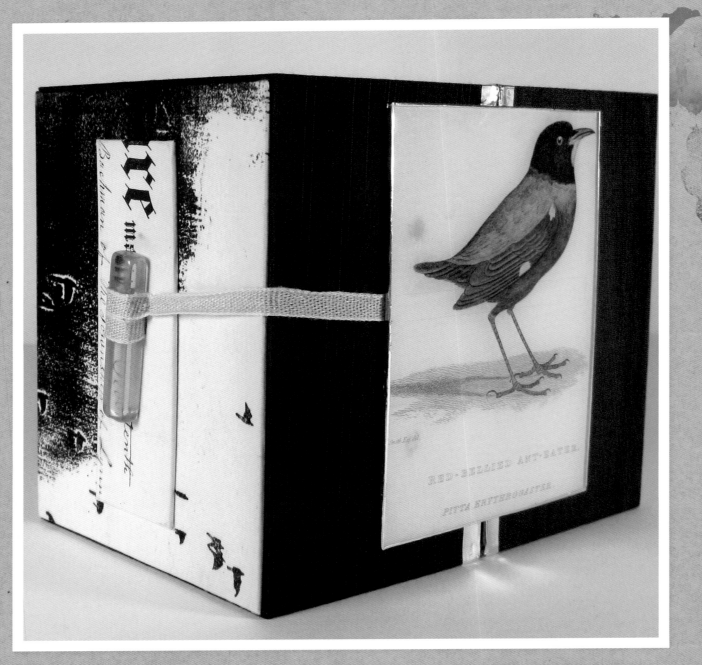

RED-BELLIED GNATCATCHER
5" × 6" × 7" (13cm × 15cm × 18cm)
Box structure, book board, book cloth, paper, antique papers, linen, plexi bead, goose egg, raffia, antique toy bees, acrylic, painted wooden bead

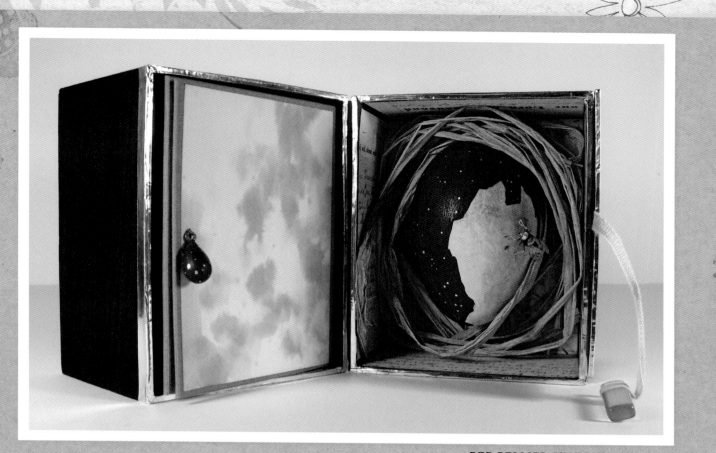

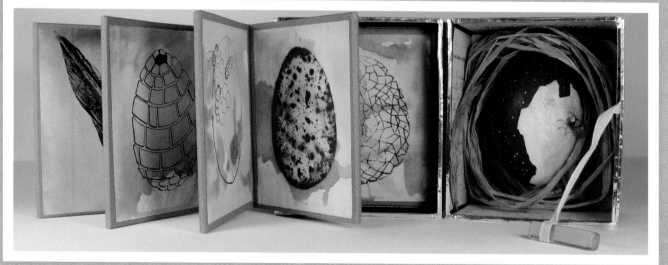

Combine Different Types of Journals

This accordion structure was made with book board and book cloth, then built into a box. You could make a similar structure by attaching accordion-fold pages into the shallow side of a cedar cigar box and adding a three-dimensional arrangement of objects into the deeper part of the box.

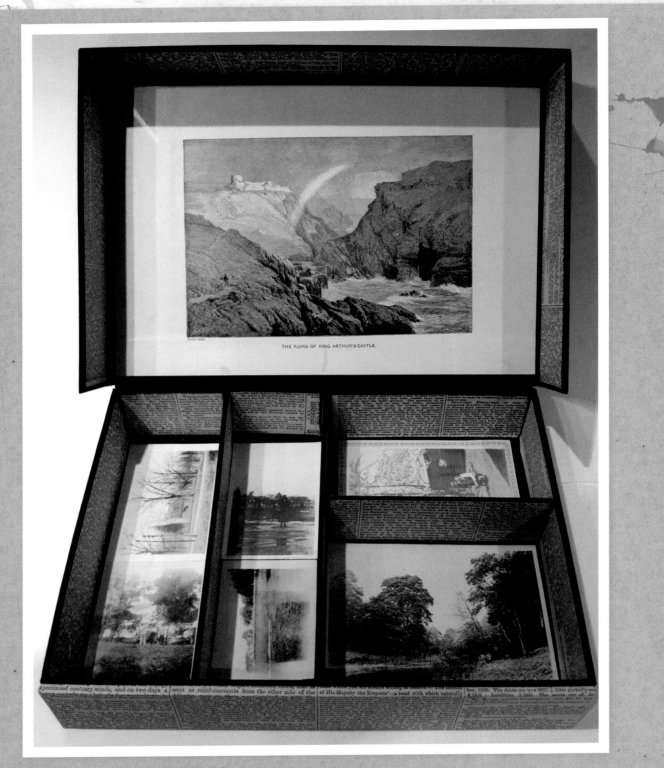

THE RUINS OF KING ARTHUR'S CASTLE.

Box Journals Can Serve Many Purposes

This simple tray variation with a hinged lid holds a collection of old photographs that I use in collages and faux family album journals, as well as to decorate other boxes.

PICTURE BOX
8" × 10" × 2"(20cm × 25cm × 5cm)
Book board, book cloth, antique papers, photographs, Plexiglas

Receive downloadable bonus materials when you sign up for our free newsletter at artistsnetwork.com/Newsletter_Thanks.

Journal With a Partner

My son and I went to the Christo installation in the park and to the Museum of Natural History. Later, we found some old steamer trunks on the street in the garbage whose tags we appropriated. I drew the snow drops I saw in the park. This kind of art journal is a fun one to do with a child—you each can have a shoebox and make your outings about observing and collecting.

SHOEBOX COLLECTIONS JOURNAL, PAGE DETAIL
11" × 15" (28cm × 38cm)
Pamphlet-sewn pages, mixed media

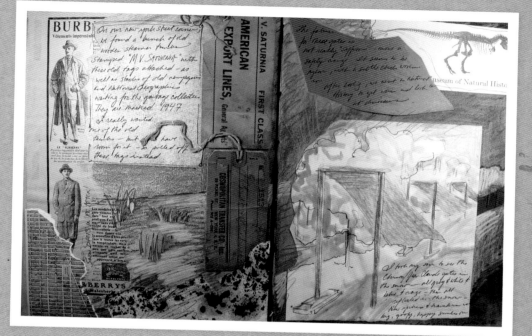

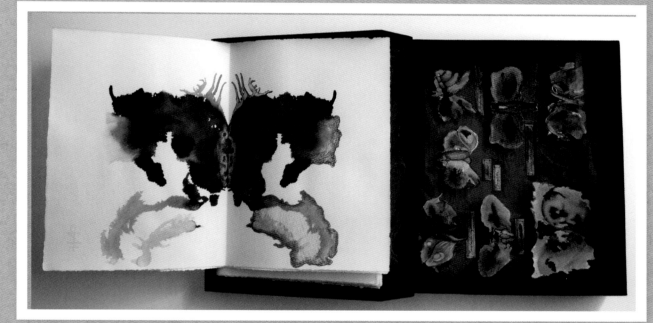

A Naturalist's Box

This fantasy collection of inkblot insects includes a careful catalogue and large detailed drawings of each winged creature included in unbound folios.

INKBLOT INSECT COLLECTION
11" × 8" × 2" (28cm × 20cm × 5cm)
Book board, book cloth, antique papers, styrene, marbleized paper, inkblots mounted on wooden blocks, beads, acid-free art paper, ink, colored pencil

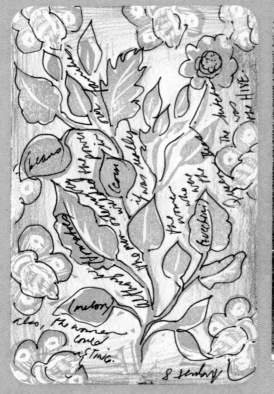

Enhance Your Journal With Rubber Stamping

Carved rubber stamps of bees, bugs and flowers were used in different combinations to create this card set journal.

IN THE GARDEN, DETAIL
4" × 7" (10cm × 18cm)
Rives BFK, rubber stamping, colored pencil, ink, gouache resist

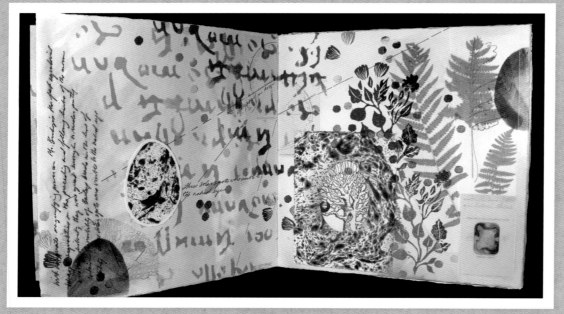

Stenciling Creates Interesting Effects

This page is stamped, stenciled and collaged with found as well as made objects. The lettering stencil that makes up most of the background is made from an enlarged sample of Leonardo da Vinci's backwards handwriting.

ASTRONOMY, PAGE DETAIL
12" × 12" (30cm × 30cm)
Coptic-bound sketchbook, mixed media

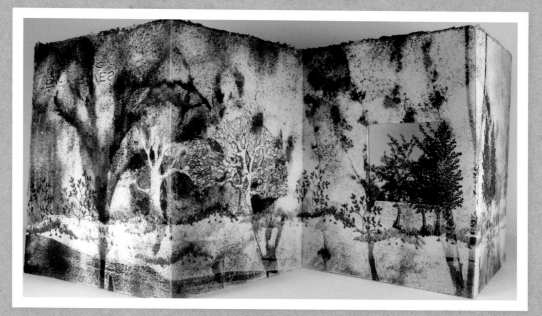

Create Texture With a Gouache Resist

The black and white tree texture is made using gouache resist. Tree and grass stamps and an antique photo of trees define the monochrome scene.

CONCERTINA FOLIO
8" × 30" (20cm × 76cm)
Lemon juice aging, stamping, India ink, antique papers and photographs

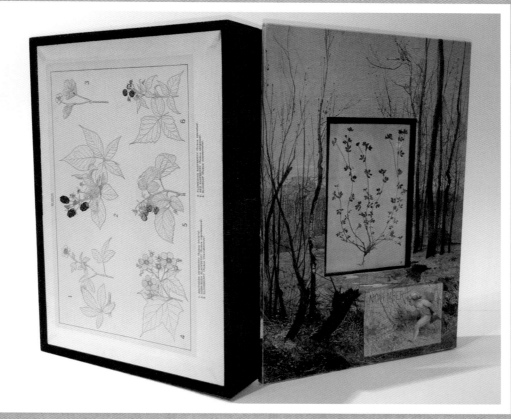

Innovation Meets Tradition

The hinged structure of this box journal makes it perfect for sliding onto a shelf with other, more traditional sketchbooks.

NOVEMBER
10" × 7" × 2" (25cm × 18cm × 5cm)
Book cloth, book board, antique papers, styrene

Visit artistsnetwork.com/AlternativeArtJournals for a bonus demonstration by Margaret Peot. **119**

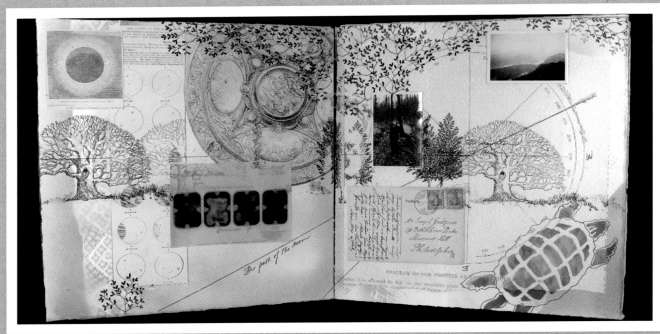

Embrace the Awkward Stage

These sketchbook pages went through an "ugly" stage. I covered what I did not like with a color copy of an old pie chart, then worked into that with stencils, collage materials, paint and text.

You may find that some of your pages have to go through an awkward stage before they look just right to you. View this as an open door filled with potential. Sometimes thinking that you have wrecked something can make you bold. After all, an ugly page has nowhere to go but up, right?

ANATOMY, PAGE DETAIL
12" × 12" (30cm × 30cm)
Coptic-bound sketchbook, collage and mixed media

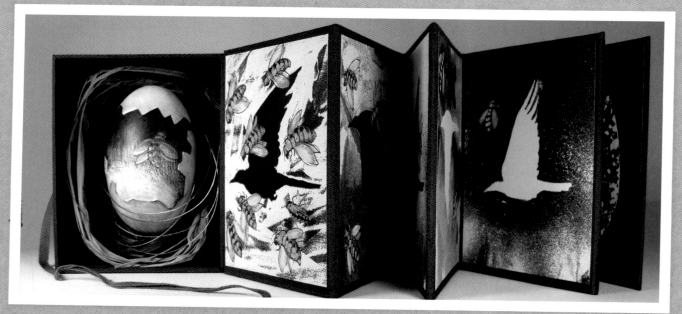

Think About Display When Choosing Materials

The accordion/box combo is made with rectangle "pages" of book board bound together with book cloth. I had to make a couple of mockups to figure out how far apart to place the pages so that the accordion closed easily. The rigid materials used allow for much flexibility with its display.,

**THE BIRD AND
THE BEES**
5" × 6" × 7" (13cm × 15cm × 18cm)
Box structure, book board, book cloth, paper, inkjet-printed papers, linen, painted goose egg, raffia, silver wire, acrylic, dye, colored pencil

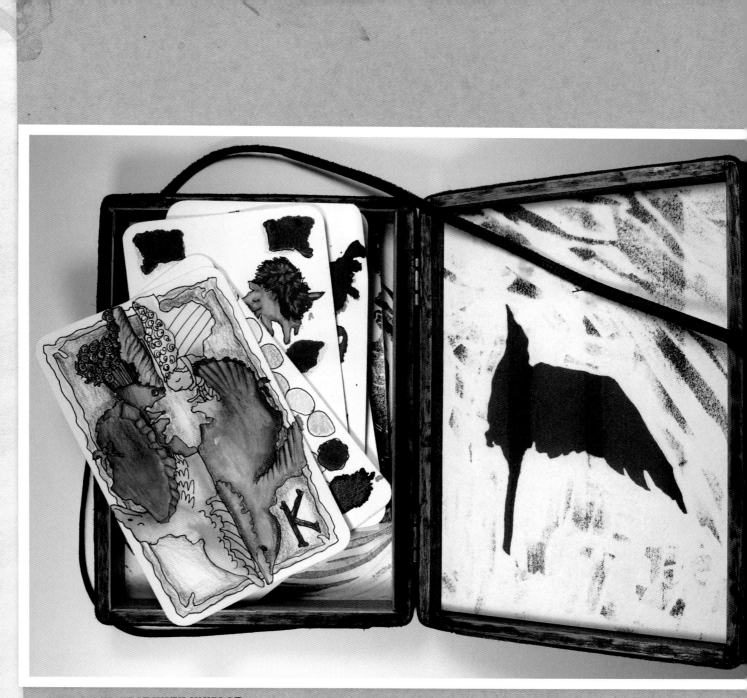

BIRD AND NEST WITH INKBLOT TAROT

Inkblot Tarot: Rives BFK paper, India ink, pen and colored pencils
Bird and Nest: Cigar box, leather, acrylic paint, paper, gouache, India ink

Journal Within a Journal

The *Inkblot Tarot* card journal currently lives in the *Bird and Nest* box journal.

Conclusion

Whether you use a traditional sketchbook to record your ideas, one of the alternative structures in this book, or a combination of these, continue exploring until you find the system that best suits you. The techniques, lessons and demonstrations covered here are intended to show you that the traditional sketchbook is not the only way to collect your artistic ideas and flights of fancy.

However, this book just skims the surface of all the possibilities. You might make an art journal that is the petals of paper flowers stitched to stems and stored in a florist's box. Your art journal could be writings and drawings on wooden disks tucked away in a fabric pouch like pirate treasure, or a series of tiny books in hundred of pockets on a vest, like secrets sewn into a hem. You might create a structure that opens like a lotus, spins like a pinwheel, or flutters in the breeze like a flag. There is as much variation in the possibilities for art journals as there are artists to make them.

Further Reading

Making Memory Boxes: Box Projects to Make, Give and Keep

Barbara Mauriello

Rockport Publishers, 2000

Non-Adhesive Binding: Books without Paste or Glue

Keith A. Smith

Sigma Foundation; 3 Rev Exp edition, 1999

Japanese Bookbinding: Instructions From a Master Craftsman

Kojiro Ikegami

Weatherhill, 1986

The Journal Junkies Workshop: Visual Ammunition for the Art Addict

Eric M. Scott, David R. Modler

North Light Books, 2010

Wreck This Journal

Keri Smith

Perigee Trade, 2007

Quentin Roosevelt's China: Ancestral Realms of the Naxi

Christine Mathieu, Cindy Ho

Arnoldsche Verlagsanstalt, 2011

Make Your Mark: Explore Your Creativity and Discover Your Inner Artist

Margaret Peot

Chronicle Books, 2004

Inkblot: Drip, Splat and Squish Your Way to Creativity

Margaret Peot

Boyds Mills Press, 2011

Joseph Cornell: Master of Dreams

Diane Waldman

Harry N. Abrams, 2006

The Griffin and Sabine Trilogy: Griffin and Sabine; Sabine's Notebook; The Golden Mean

Nick Bantock

Chronicle Books, 1994

Index

Photograph by Peter Robertson.

ABOUT THE AUTHOR

Margaret Peot is a painter, printmaker and writer who has been making her living as a freelance artist for more than twenty years. She is the author of *The Successful Artist's Career Guide: Finding Your Way in the Business of Art*, published by North Light Books, containing interviews with other artists, personal anecdotes, worksheets and practical advice for making a living as a visual artist. Her book for kids, *Inkblot: Drip, Splat and Squish Your Way to Creativity*, published by Boyds Mills Press, shows all the fun things to make a do with inkblots, and *Make Your Mark: Explore Your Creativity and Discover Your Inner Artist* (Chronicle Books) contains no-fail, no-drawing-necessary techniques designed to jump-start creativity.

Margaret has been painting and dyeing costumes since 1989 for Broadway theater (*Spiderman: Turn Off the Dark, The Lion King, Wicked, Shrek The Musical, Spamalot* and hundreds of other projects), dance (San Francisco Ballet's *The Nutcracker, Pilobolus*), television, film (*Bram Stoker's Dracula*) and circus (Ringling Bros. and Barnum and Bailey and The Big Apple Circus). She is a member of United Scenic Artists, and has taught costume painting at Tisch School of the Arts at New York University.

Margaret lives in New York with her husband, Daniel Levy– and their son Sam. Visit her website at margaretpeot.com.

Other fine North Light Books are available from your favorite bookstore, art supply store or online supplier. Visit our website at fwmedia.com.

16 15 14 13 12 5 4 3 2 1

DISTRIBUTED IN CANADA BY FRASER DIRECT
100 Armstrong Avenue
Georgetown, ON, Canada L7G 5S4
Tel: (905) 877-4411

DISTRIBUTED IN THE U.K. AND EUROPE
BY F&W MEDIA INTERNATIONAL, LTD
Brunel House, Forde Close, Newton Abbot
TQ12 4PU, UK
Tel: (+44) 1626 323200, Fax: (+44) 1626 323319
Email: enquiries@fwmedia.com

DISTRIBUTED IN AUSTRALIA BY CAPRICORN LINK
P.O. Box 704, S. Windsor NSW, 2756 Australia
Tel: (02) 4577-3555

Edited by **CHRISTINA RICHARDS**
Designed by **RONSON SLAGLE**, **KARLA BAKER** AND
ELYSE SCHWANKE
Production coordinated by **MARK GRIFFIN**

Metric Conversion Chart

TO CONVERT	TO	MULTIPLY BY
Inches	Centimeters	2.54
Centimeters	Inches	0.4
Feet	Centimeters	30.5
Centimeters	Feet	0.03
Yards	Meters	0.9
Meters	Yards	1.1

Receive downloadable bonus materials when you sign up for our free newsletter at artistsnetwork.com/Newsletter_Thanks

ACKNOWLEDGMENTS

I would like to extend a special thank you to three of the wonderful teachers at The Center for Book Arts in New York City: Barbara Mauriello, Robert Warner and Zahra Partovi.

Thanks to Barbara for teaching me so many book and box structures and opening my mind with her witty use of color and pattern.

Thanks to Robert for introducing me to the flea market on 26th Street in NYC, and to the joys of working with antique papers.

Thanks to Zahra for teaching me the coptic book structure, without which I would be lost!

Thank you to Ardis Macaulay who always encourages me to think beyond traditional forms.

Thanks also to my agent Anna Olswanger for her enthusiasm and support, and my editor Christina Richards for her care and attention to detail.

Thanks to the Hermitage Artist Retreat for providing such a lovely, calm place to work, and to Maggie Probst and Denise Clemons, for letting me walk with them on their turtle patrol route.

Thanks to Sue Seitner who loves to make things and inspires me.

And, as always, the biggest thanks goes to Hans and Kathie Peot, and Daniel and Sam Levy.

DEDICATION

For Ardis.

Visit artistsnetwork.com/AlternativeArtJournals for a bonus demonstration by Margaret Peot.

127

IDEAS. INSTRUCTION. INSPIRATION.

Receive **FREE** downloadable bonus materials when you sign up for our free newsletter at artistsnetwork.com/Newsletter_Thanks.

These and other fine North Light products are available at your favorite art & craft retailer, bookstore or online supplier. Visit our websites at **artistsnetwork.com** and **artistsnetwork.tv.**

Follow North Light Books for the latest news, free wallpapers, free demos and chances to win **FREE BOOKS!**

Visit artistsnetwork.com and get Jen's North Light Picks!

Get free step-by-step demonstrations along with reviews of the latest books, videos and downloads from Jennifer Lepore, Senior Editor and Online Education Manager at North Light Books.